The
President
&
Mrs.
Reagan

An American Love Story

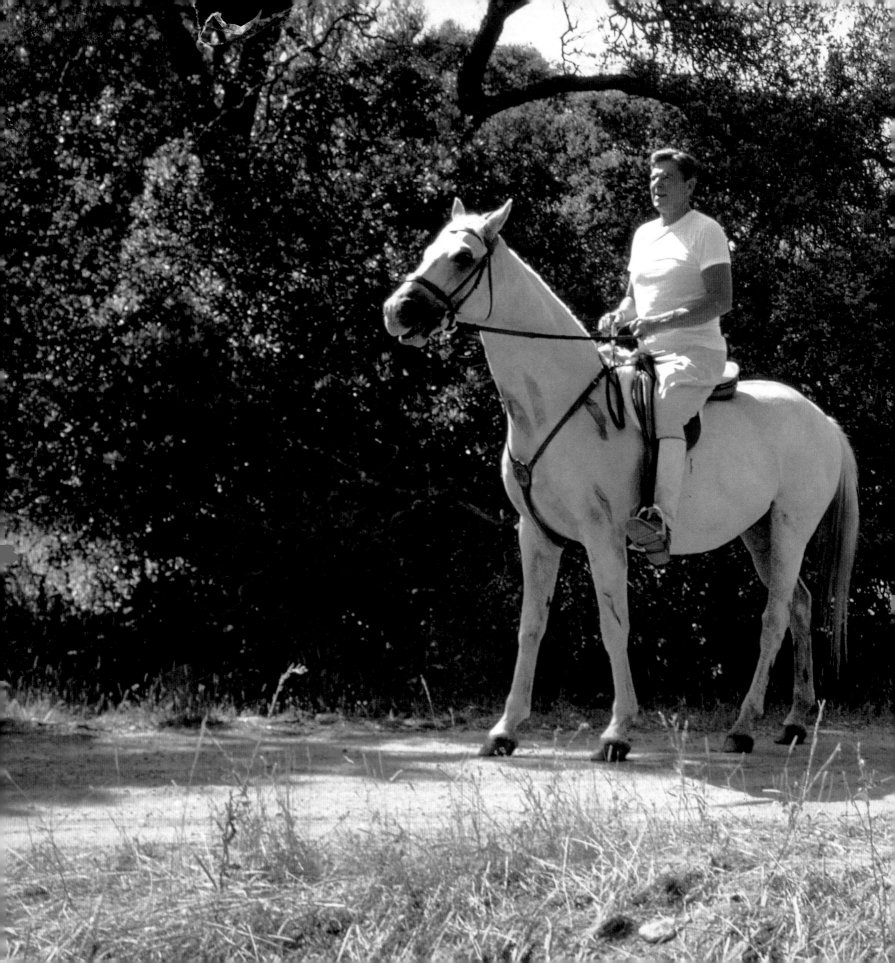

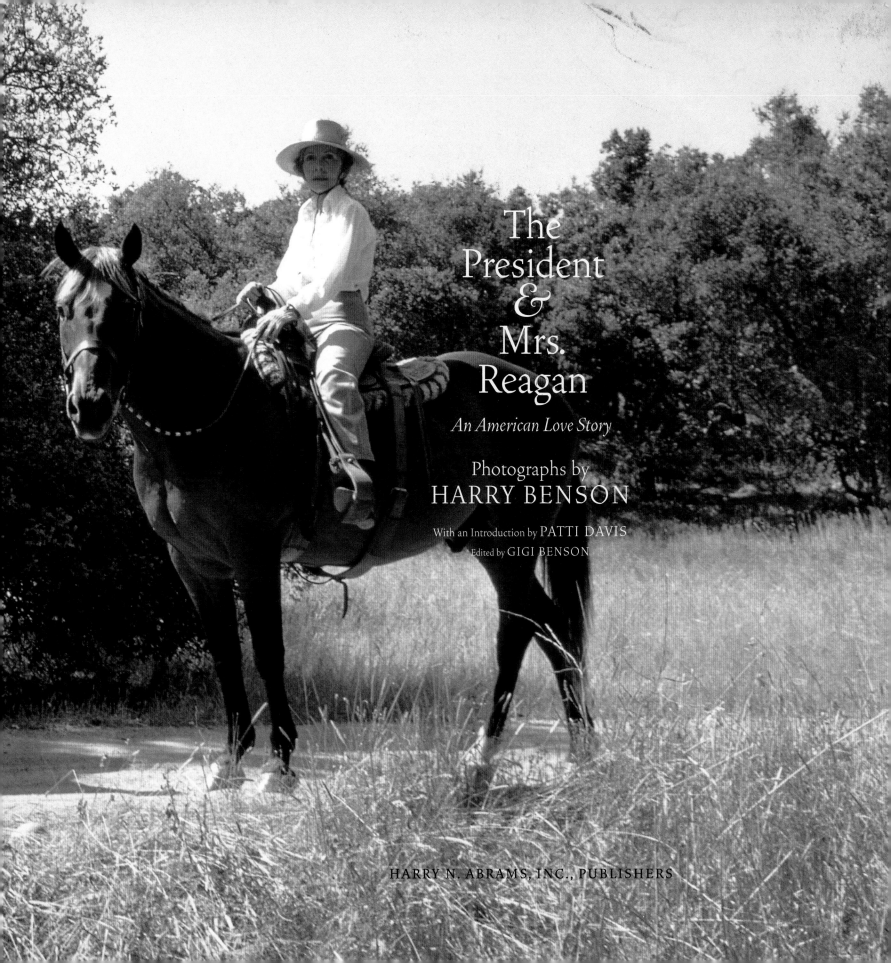

The
President
&
Mrs.
Reagan

An American Love Story

Photographs by
HARRY BENSON

With an Introduction by PATTI DAVIS
Edited by GIGI BENSON

HARRY N. ABRAMS, INC., PUBLISHERS

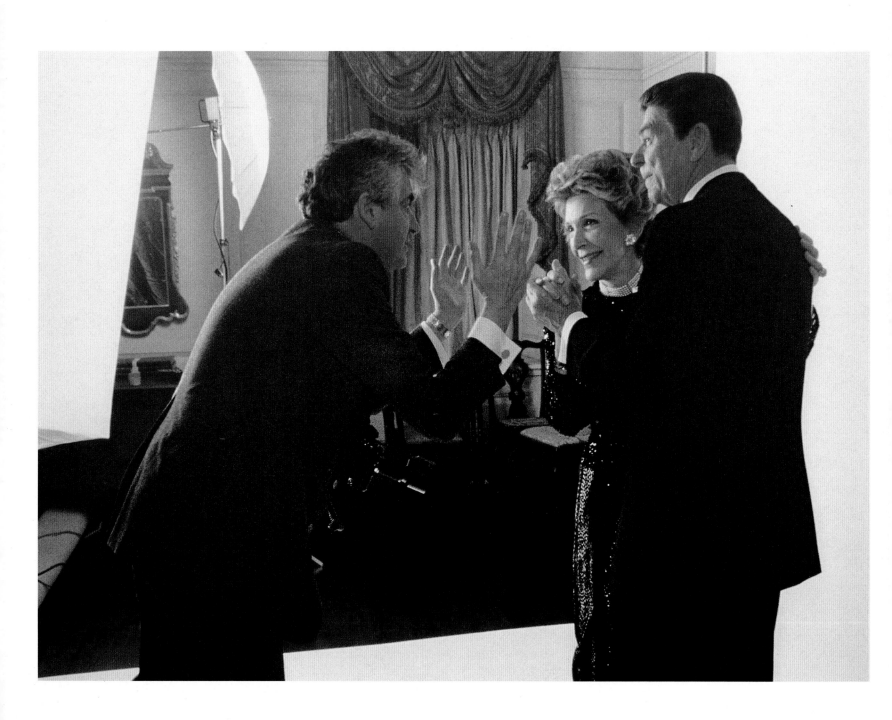

Harry with the president and Mrs. Reagan in the White House in 1985

To my daughters, Wendy and Tessa, with love

I WOULD LIKE TO thank Eric Himmel, Abrams' editor-in-chief; Michael Walsh, art director; Arlene Lee, designer; and Gail Mandel, editor, for their invaluable help. Working with such a team has been a privilege.

To my wife, Gigi, who painstakingly edited almost forty years of photographs for this book, and to photographer Jonathan Delano, who was with me when I took many of them, my thanks.

To the editors who gave me the assignments and made it possible for me to take the photos—I just wouldn't have a book without them: John Loengard, David Friend, Jean-Jacques Naudet, M. C. Marden, Bobbi Baker Burrows, Dick Stolley, Jim Gaines, Graydon Carter, David Remnick, Ed Kosner, Mary Dunn, Sean Callahan, Nik Kleinberg, Ron Bailey, Tina Brown, Jim Danziger, Karen Frank, Lanny Jones, Dan Okrent, David Breul, Ralph and Eleanore Graves, David Schonauer, Susan Vermazen, Manuela Suarez, Stef Heckscher, Mel Scott, David Sherman, Marie Schumann, Jay Lovinger, and Ralph Morse. Thanks also to the writers who traveled with me on the assignments: Margot Dougherty, Judy Fayard, Kristen McMurran, Steve Robinson, Doris Kenney, and Chris Whipple.

Thanks to Sam Kusumoto, Phil Seltzer, Lou Desiderio, Mike Newler, David Cairns, Igor Bakht, and Zee Moran.

To my mentor, Lord Beaverbrook, and to Sir Max Aitkin, Frank Spooner, Michael Rand, Freddy Wackett, Ivor Davis, Victor Davis, Ian Brodie, Stephen Claypole, Sarah McDonald, Matthew Butson, James Charnock, Brian Doherty, Harold Keeble, Derek Marks, Derek Lambert, Bob Edwards, Peter Baker, Tom Murray, and Len Franklin, my thanks.

I would especially like to thank Patti Davis for a wonderful introduction to the book. And of course, to President and Mrs. Reagan, I offer my sincere thanks for the privilege and fun of photographing them over the years.

Introduction

ANTOINE DE SAINT-EXUPÉRY SAID, "The life of the past seems to us nearer our true natures, but only for the reason that it is nearer our language."

In the hands of an intuitive and sensitive photographer, a camera is more than a tool—it's a guide. It can take us deeper into people—beneath their eyes, their smiles, the facial expressions they have composed for the world. It might be just a split second when the subject has turned a bit, or has given in to an errant thought, a daydream, or has slipped away into a memory, that his guard is let down revealing more about himself—or herself. It's an instant that can so easily be missed, but a photographer must be alert, insightful, patient…and I suppose confident that what is deeper than the eye will be revealed when the film is developed. Such photographic revelations are the result of the intimate relationship that is forged between photographer and subject.

Harry Benson is such a photographer who has nurtured a relationship of this kind with my parents over many decades, as the pictures in this book show. Because he

looks through the lens with more than just his eyes, the camera becomes a language our hearts understand. Would my parents have danced and laughed so easily, so freely, with someone else on the other side of the camera? Possibly not, because trust is a powerful elixir. There is something unmistakably informal and casual about the pictures of my parents, in these pages, dressed in their formal evening attire. It is almost as if they were alone in the privacy of their living room. Almost as if they had forgotten about the camera. Yes, it's the leader of the free world and the first lady, but what you see, what stays with you, is the image of a couple delighted with each other, happily having fun and, as trite as it sounds, kicking up their heels.

Growing up in a well-known family, which was destined to become even more famous, I got used to the frequent presence of a camera. In fact, it was so firmly entrenched in our lives that it took me many years to really appreciate and understand, as my parents did, how valuable photographs can be. They are windows, portals, links to memory. They are a way to feed our souls when we feel a vague, existential hunger.

Time remolds us; it's the alchemist we can't defy or bargain with. We will never again be as young as we were in a picture taken long ago, or even yesterday. One day, we look at images from the past, and see with more than just our eyes. We see with our hearts. We stare back down the years and realize how tall our parents looked to us when we were small or how wide the sky seemed. We see beloved pets that passed away years ago, or homes that were once ours and are now either inhabited by other families, or gone completely. We can touch again the edges of moments, hours—times we hadn't forgotten but don't always remember to revisit.

There are always stories behind photographs. Even if you don't know the person in the picture, you might imagine what they're smiling at, or what made them laugh or furrow their brow. If you do know the person, there is a delicious uncorking of memories.

Framed photographs graced the walls and surfaces wherever my family set down roots. When I was a child, our ranch in Malibu Canyon had a ramshackle house—small, with no discernable foundation—but it was filled with photographs. We didn't usually sleep at the ranch house—we came out on Saturdays (my father came occasionally during the week). It was a daytime house, so we didn't have to compete with the mice. Nevertheless, the photos decorated the walls of the main room—black-and-white movie stills of my father's films, and my mother's, although she did less than my father.

The images are still stamped on my memory—my father with a teenage Shirley Temple, Doris Day, or Ann Sheridan. My mother with James Whitmore, and with my father in the one film they made together, *Hellcats of the Navy*. When one of Malibu's dangerous fires was racing toward our property, my parents drove out to rescue the photographs in case the house burned to the ground.

(When the famous Bel Air fire on November 6, 1961, threatened our Pacific Palisades home, we loaded up the car with photographs and family albums in case we had to evacuate. I'm sure there were important documents in the car as well, but what I remember are the photographs. I accepted that these were the things people tried to salvage when disaster loomed. I accepted it, but I didn't fully understand.)

In these pages you will find a picture taken in 1966 of my father approaching a young horse in a fenced pasture. The horse's name was Little Man, the foal of Nancy D—the dapple-gray mare that my father named after my mother. It was taken at the Malibu Canyon ranch, a heaven-on-earth where we could ride and run through long, lazy days. The ranch was inland from the coast, a half-hour's drive from the Pacific Coast Highway along a swath cut between blue mountains. We traveled from gray fog into yellow sunlight, leaving behind the bristle of the sea

for the feathery smells of oak trees, hay, warm-baked earth. These are the scents of my childhood. It was at this magical place that in my youth my brother and I scooped tiny frogs into our hands from the mud embankment of the duck pond, giggling when they leapt out, back into the thick black ooze. You would have had to ride most of the day, or take a very long jeep ride, to reach the ends of our property.

What you don't see in the picture of my father is the plum tree near that fenced pasture, just outside of the rickety ranch house. In the summers we picked plums from the branches and bit into the sweetest fruit we had ever tasted. Purple juice ran down our chins and made our fingers sticky and sweet. You also don't see the oak grove—farther away, along one of the paths we took when we went horseback riding. The trees were so dense and old, only ribbons of sunlight came through the leaves. What you don't hear is my father's voice gently soothing Little Man as he walks up to him. I know the lilt of his words were balanced on the breeze that afternoon, because the horse was young, and my father used his voice brilliantly, measuring it to either calm or train our animals. I see and hear all of that and more in the one photograph—it spirals me back through the years to days that once seemed as easy and endless as forever.

There were lilac bushes around that ranch house—they bloomed happily and prodigiously. Their perfume hung in the air, and we would bring armfuls of them back home to Pacific Palisades with us. I can still picture in my mind our red station wagon and us driving back along the mountainous road, children and dogs in the back, while the hypnotic scent of lilacs trailed out through the open windows.

Years later, a different ranch in Santa Barbara—Rancho del Cielo—became my parents' refuge, until my father's illness necessitated its sale. At that ranch, it was the smell of wood-smoke that sweetened the air almost all of the time. The small adobe house, which fortunately did have a foundation, had no heat except for fireplaces. So, even on warm summer evenings, you could wander outside, watch the sun drop behind the hills, listen to the deep, abiding silence, and catch the smell of oak logs burning in at least one of the fireplaces. On cold winter mornings, it was the first smell you woke up to, and you knew it would drift around you for the rest of the day.

When I look at the photograph of my father outside that house, obviously in the midst of explaining something, his arm extended, I imagine him talking about the man-made lake, just thirty feet or so from the house. How perfect that he would choose to build a lake there. He grew up along the Rock River in Illinois—ice-skated on it in frozen winters, swam in it during the summer, and when he got older, worked as a lifeguard there. To him, no place was complete without a body of water. His remedy for a ranch that didn't have a body of water? Build one.

Look at the photographs of my parents and their canoe. The canoe came about because my mother's childhood fantasy was to receive a marriage proposal in a canoe, with her prospective husband playing a ukulele. Canoes were not abundant in Hollywood during the 1950s, when my father proposed to my mother, and he probably didn't know about her fantasy then anyway. But having learned about it over the years, he lovingly built a dock on the lake and tied a canoe to it. The photographs of my father rowing my mother across their very own lake are a sweet remembrance of how romantic he could be, even after decades of marriage. She easily forgave the absence of a ukulele—who wouldn't?

To try to give you insight into my parents' relationship, I need to take you up a narrow, winding mountain road to six hundred acres, so high above city streets, so distant from busy buildings and cars honking, that it seems like a world apart. I must lead you to the slope of a hillside and ask you to listen—to the sweep of wind through the grasses, to the cry of a hawk as it dives down for its prey, to the distant yipping of coyotes, and to the silence. You would find a silence you might never have known before, because almost anywhere you go, you hear the hum of traffic and power lines. But not there. Imagine, then, letting days and weeks roll by in such a place accompanied by only one other person—your spouse, your lover. No other distractions. No running out to a movie or driving over to a friend's house for a barbecue. If you can imagine the time as happy and completely fulfilling, you have an idea of what my parents' union is like. Over the years they have been each other's nourishment and peace of mind. Look carefully at the pictures of them riding—you can see it in their faces.

If we are lucky, one day we look at our mother and father and see them as more than just our parents. We see them as people who fell in love, who were once younger than we ever believed they could be, who before we were even born, embarked on the awesome task of staying together in a world where so much is torn apart. If we are really lucky, we have photographs to help us expand our vision.

I'm one of the lucky ones. Because Harry Benson spent years occasionally dropping into my parents' lives—a trusted friend who happened to have a camera in hand, he has provided an intimate tableau. I can turn these pages of his photographs and see my parents' joy at simply being together. I can see them as people

who nurtured their love for each other every day, who knew that friendship is the mortar holding love together, who closed their eyes when they kissed, and who held hands like teenagers. The close-up photograph of their hands clasped together might be one of the most poignant for me. Because as my father leaves, slips away into the shadows of Alzheimer's, a mysterious and cruel disease, his hand still reaches for another hand to hold. His grip is still surprisingly strong, and I will always believe that he knows when it's my mother's hand he is holding.

The last photographs Mr. Benson took of my parents were at the house they live in now—in Bel Air, on a hill that affords a sweeping view of the city. My father was fond of referring to America as "the shining city on the hill." But he also liked to live up high, close to the sky and the clouds. He couldn't abide the feeling of being closed in, of having the mountains pressing upon him. There are framed photographs in this house, too, but now it's left to my mother to look at them with both fondness and sadness. My father no longer recognizes the life they led together, the moments frozen in time.

There is a photograph of my mother, in these pages, looking out of the window of the Bel Air house—the last one my parents will share together. My father too loved that view. Even as Alzheimer's was steadily devouring him, his eyes still traveled to the sky and to the city laid out below. What was my mother thinking while she gazed out of the window? Her eyes look wistful and a bit sad. Maybe she was wondering how much longer my father would be able to breathe in the wide space around them in their house-on-a-hill—how much longer his eyes would sweep across the horizon, following clouds in their path across the blue dome of sky. Alzheimer's closes the mind's eye long before one's eyes close for the last time.

Someday, decades from now, people who aren't even born yet will look at these photographs and—perhaps—wonder what my parents were laughing at, or what was going through my father's mind when he was leaning against a railing looking up at the sky. Photographs can collapse time. No matter how old a picture might be, it is a journey of discovery for the viewer. Photographs afford us glimpses into other times, other people, other lives. And, if we look very closely, we might find parts of ourselves there as well.

—Patti Davis, 2002

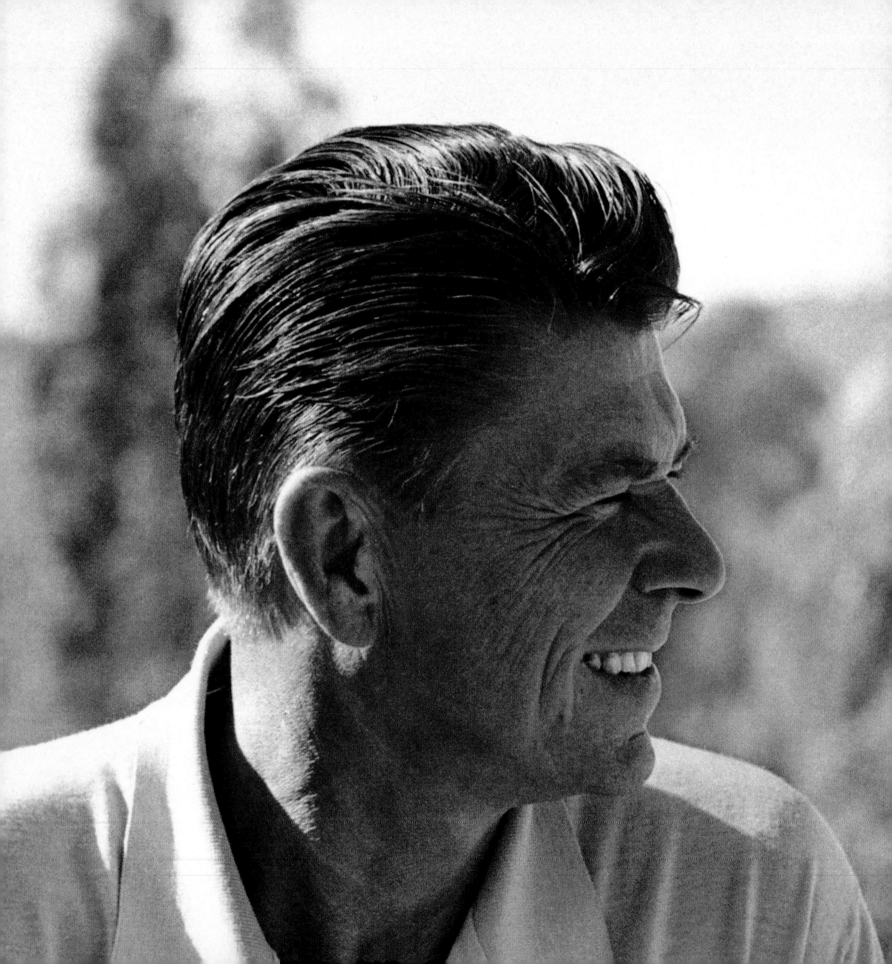

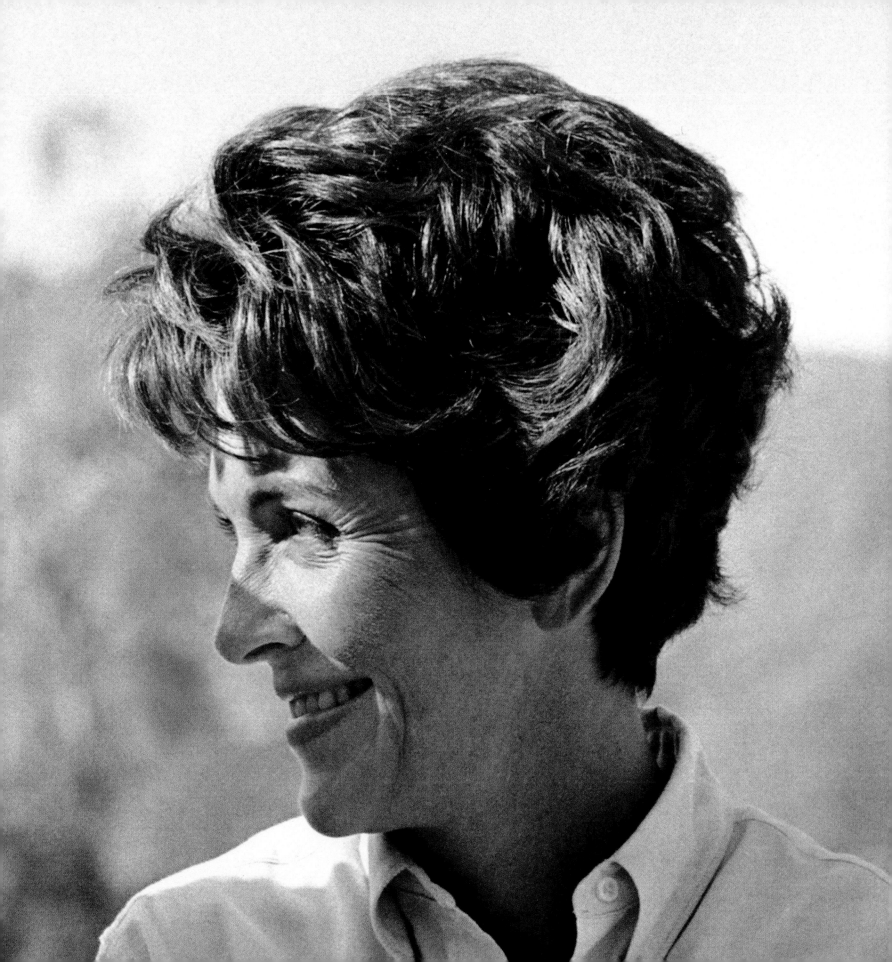

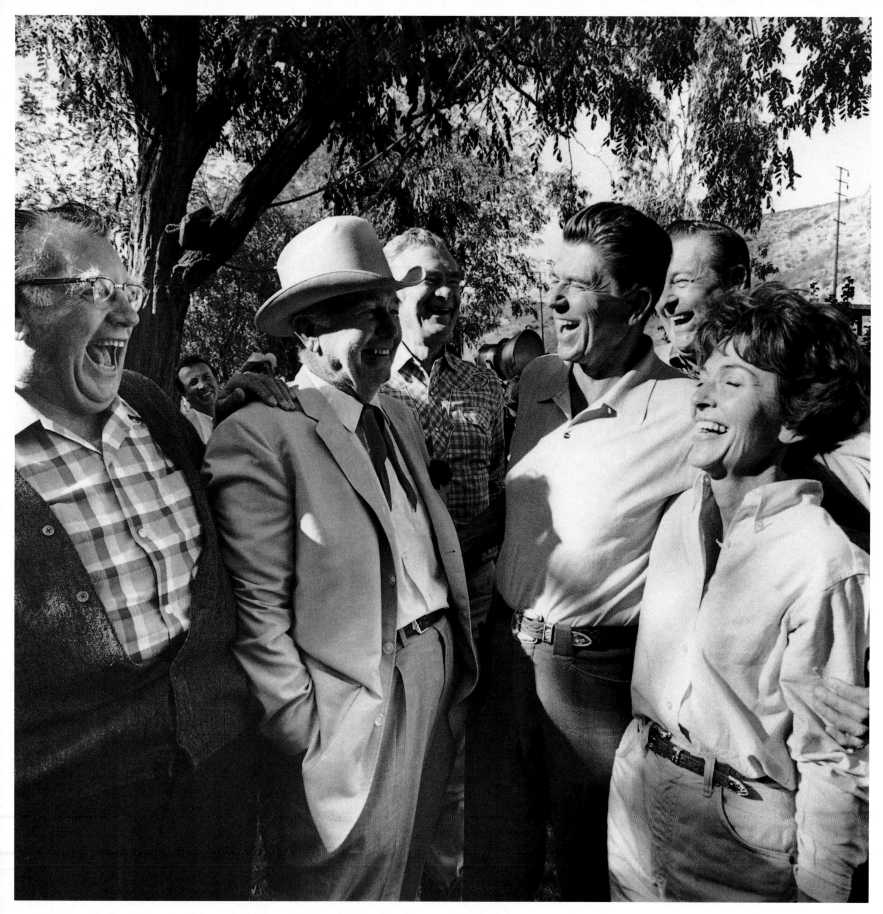

THEIRS IS A LOVE STORY—an extraordinary one I have been privileged to experience firsthand over the years. These are my favorite photographs of a couple whose love for each other is true.

When I first met Ronald and Nancy Reagan in August 1966, he was in the middle of his campaign for the governorship of California. The pair acted like newlyweds, although they had been married for fourteen years. They were hosting a barbecue at their Malibu ranch and were surrounded by friends, actors mostly who had come to support one of their own. Robert Taylor, Andy Devine, Walter Brennan, Buddy Ebsen, and Don Defore were there, laughing and posing for pictures as the Reagans greeted everyone.

It would be hard for Reagan to cross over from actor to politician, but you could see he was keen to prove he could do it. He was a movie star who had portrayed characters ranging from a football hero to a college professor; now he wanted to be a politician in real life. Only George Murphy had done it before him—a well-loved movie star who had become a United States senator from California. Senator Murphy had led the way, and Reagan meant to follow in his footsteps. Charismatic, handsome, tall, and stately (even then), Reagan, with his engaging smile, had a strong, soothing voice that let voters know he cared about their needs. In November 1966, Reagan was elected governor of the state of California with his wife Nancy Davis Reagan—an actress of considerable talent and mother of their two small children, Patti (born in 1952) and Ron, Jr. (born in 1958)—by his side. However, by the 1970s Reagan had even loftier goals in mind.

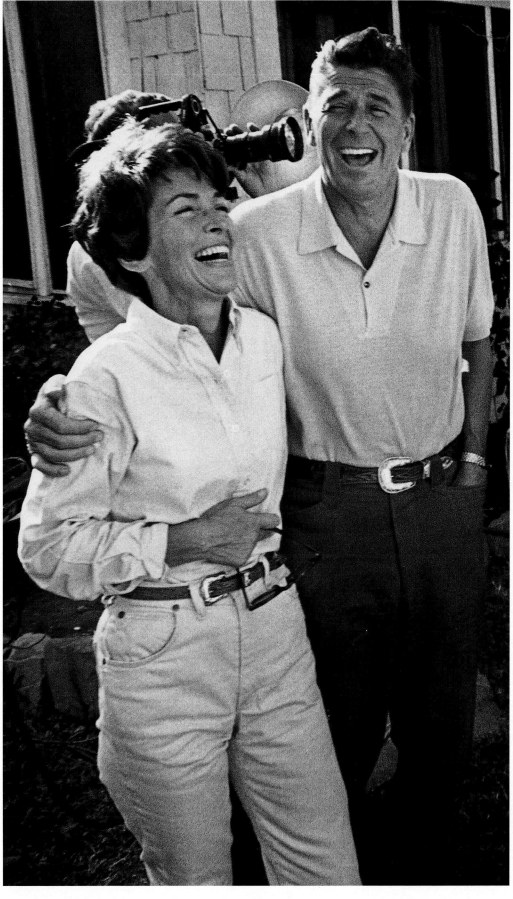

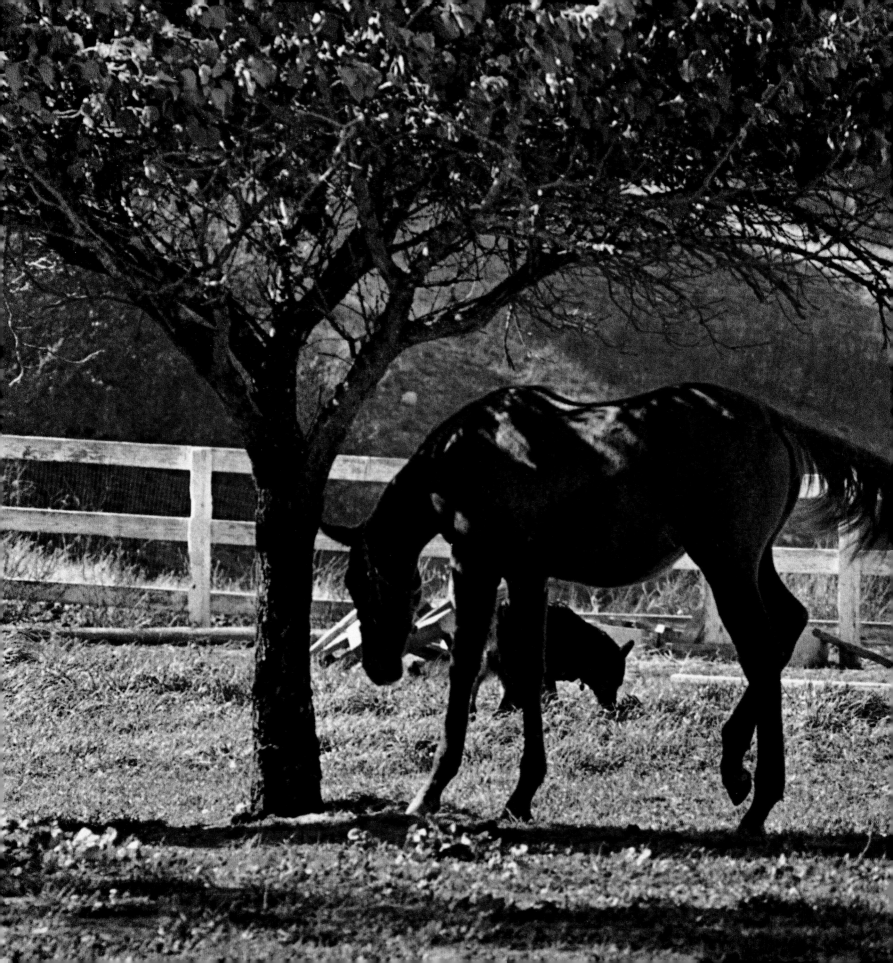

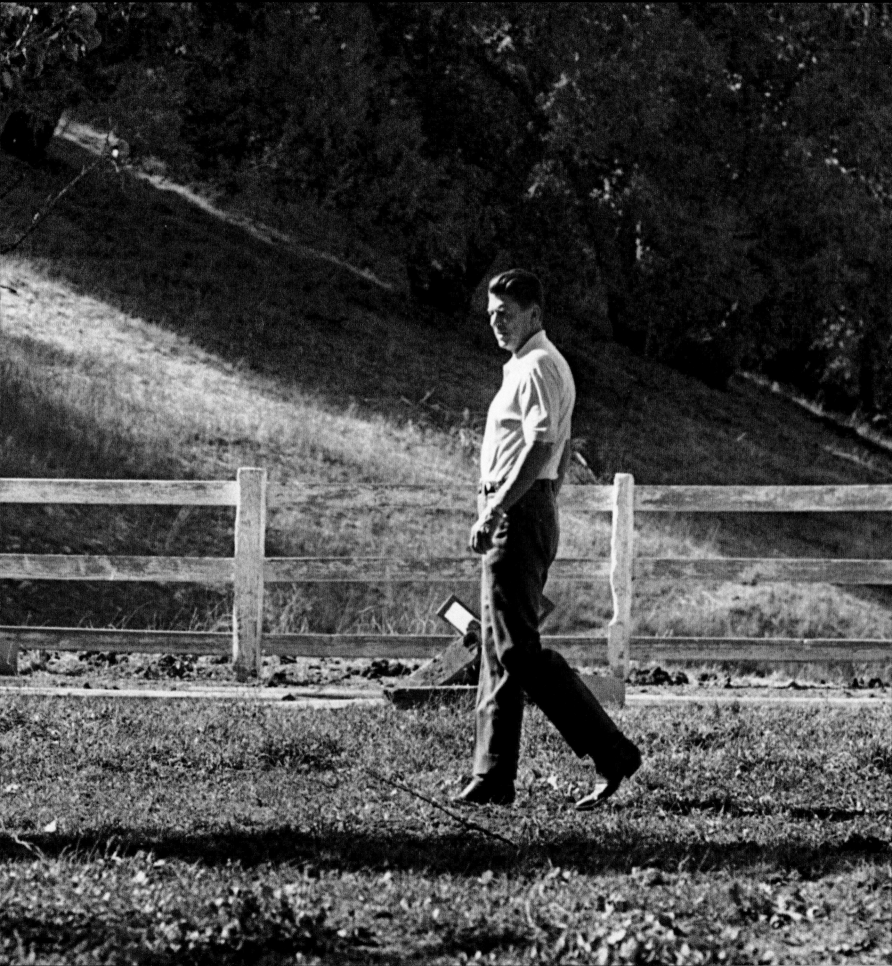

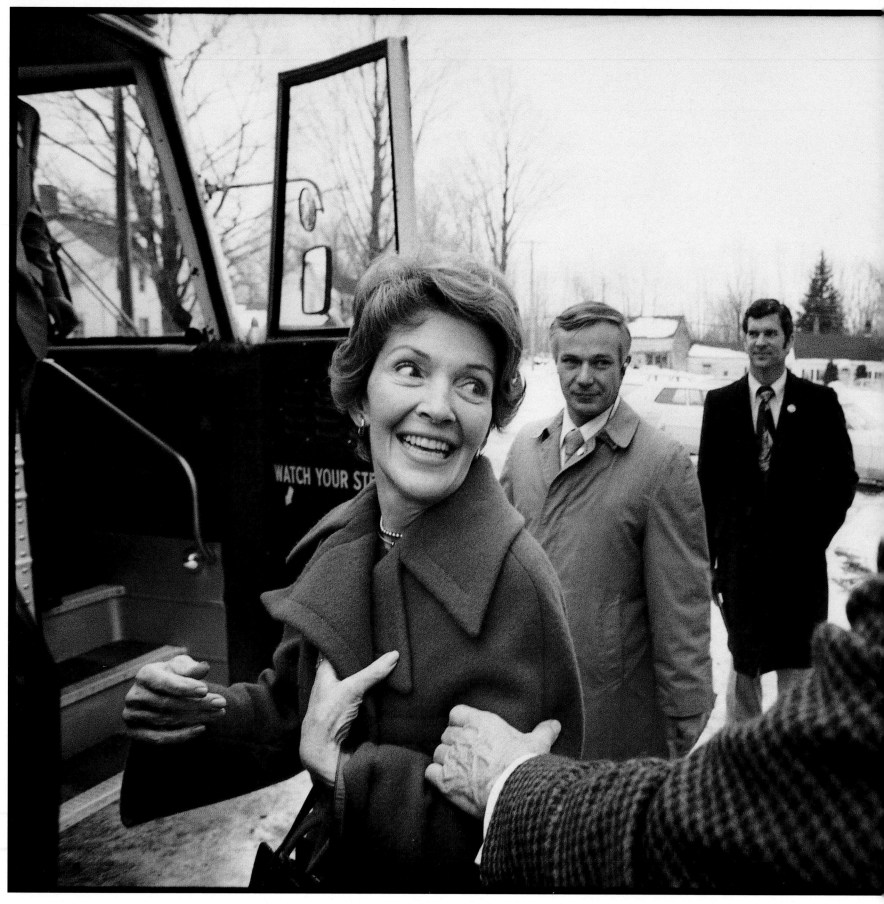

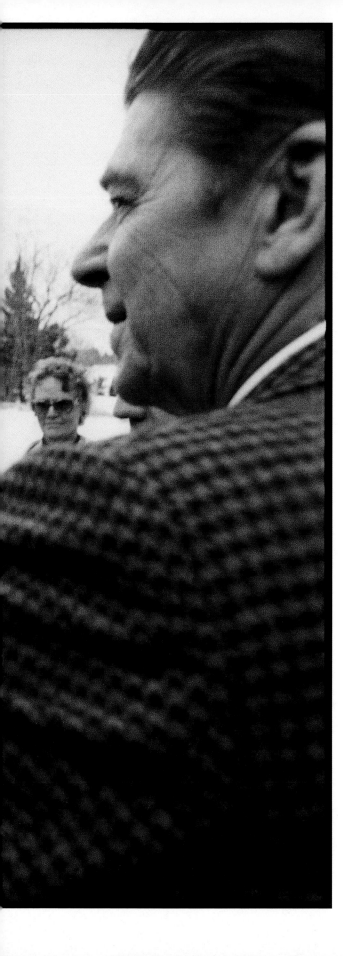

IN 1976 I TRAVELED THROUGH New Hampshire with the governor and Mrs. Reagan on their bus as he campaigned for the Republican nomination for president. The Reagans had an exhausting schedule, as the candidate geared up for the primary. We made stop after stop, weathering the bleak New England winter. Whether they were looking at maps to see where they were, grabbing a moment's rest on the bus between stops, eating cold sandwiches, or drinking coffee from paper containers, they took it all in their stride.

Reagan gave rousing speeches in town halls to enraptured voters sitting on folding chairs. He kissed babies and shook hands, all the while flashing that mesmerizing smile. Nancy was especially taken with the children they encountered. She would bend down to say hello to each one in a quiet way despite the commotion surrounding her. When each visit came to an end, Reagan would wave goodbye to the cheering fans who had come out to greet him.

That year Reagan lost his bid for the Republican presidential nomination to Gerald Ford. Ford had the chance to make Reagan his running mate but decided against it. The pundits warned Ford he was making a big mistake and they turned out to be right. Democrat Jimmy Carter was elected president. Nevertheless, I saw in New Hampshire a discipline in the Reagans that I knew would not go away. They were in it together for the long haul and their determination paid off. Four years later, Reagan was elected president of the United States. He had achieved the ultimate goal, and he and Nancy had done it together. Cold sandwiches on the bus had led to state dinners in the White House.

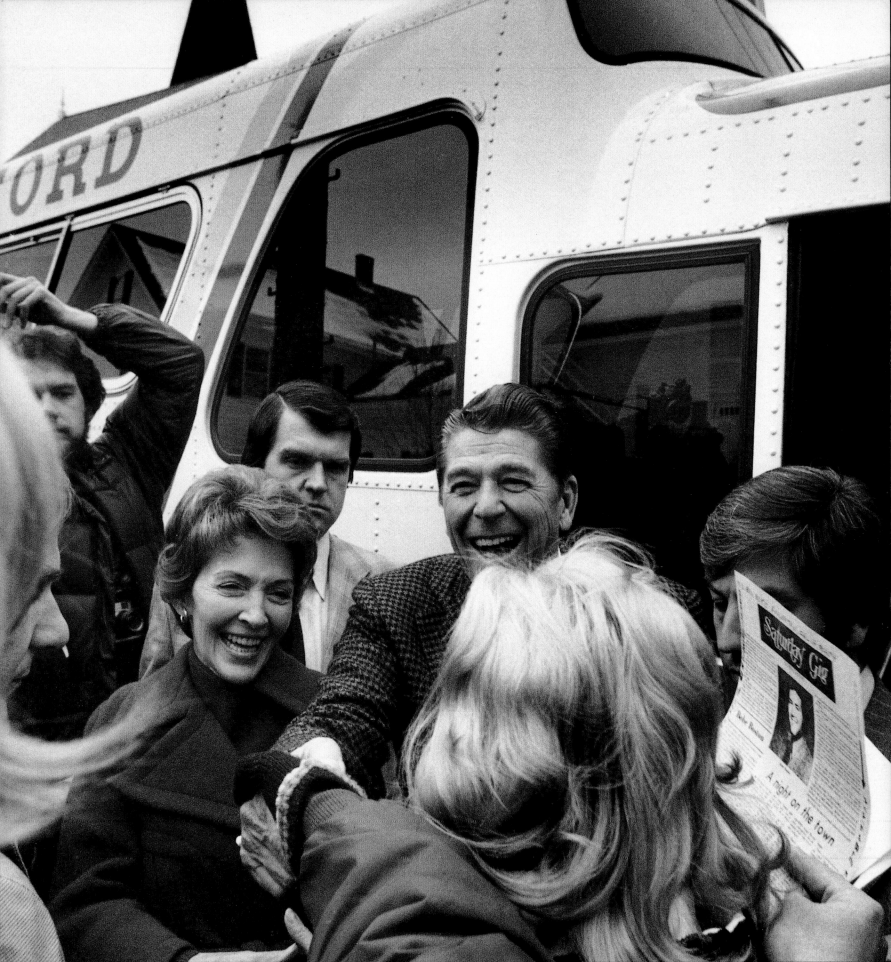

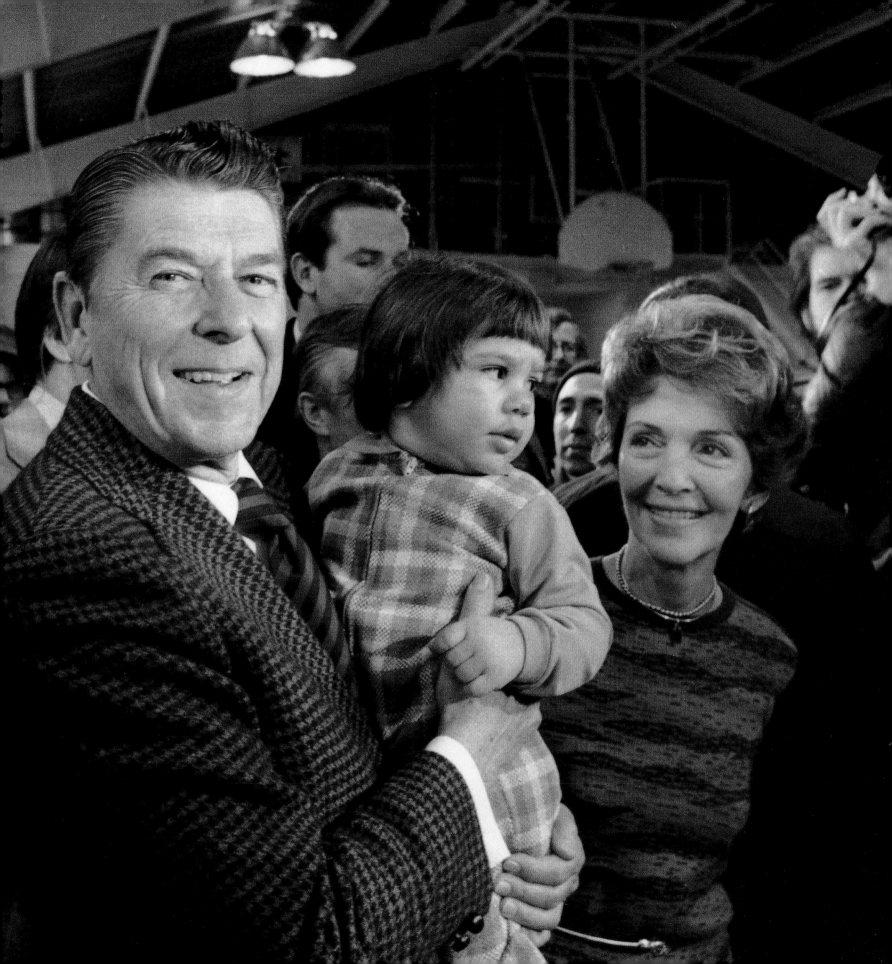

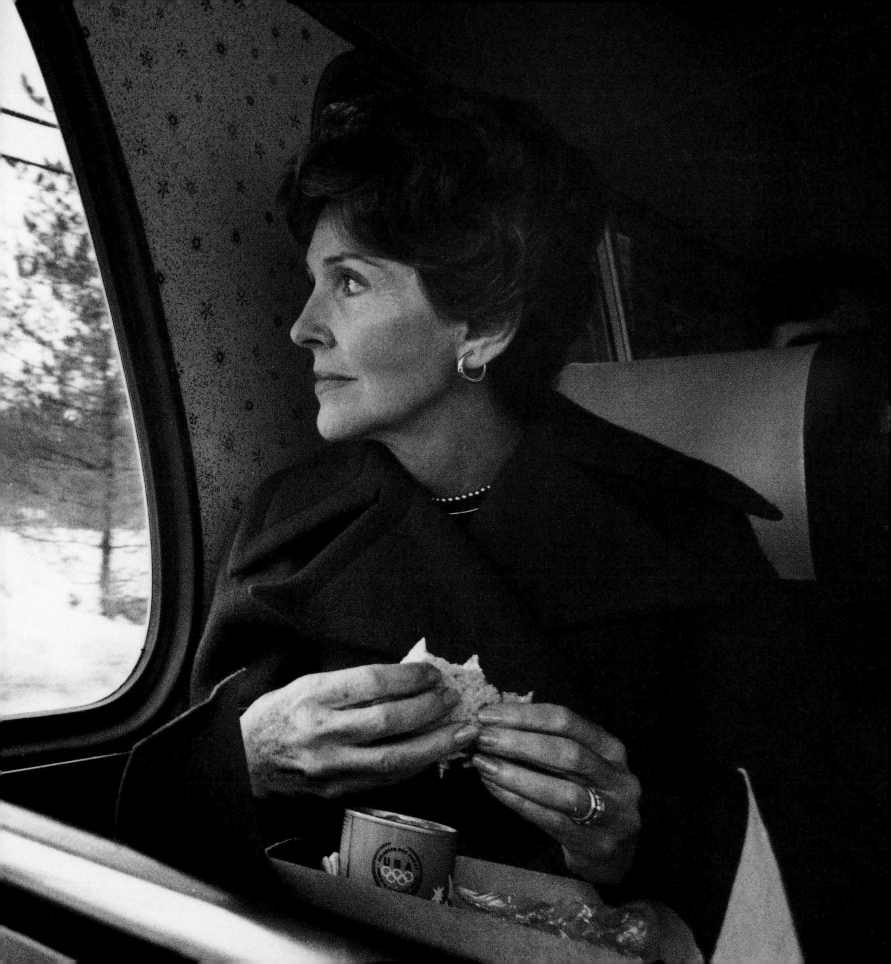

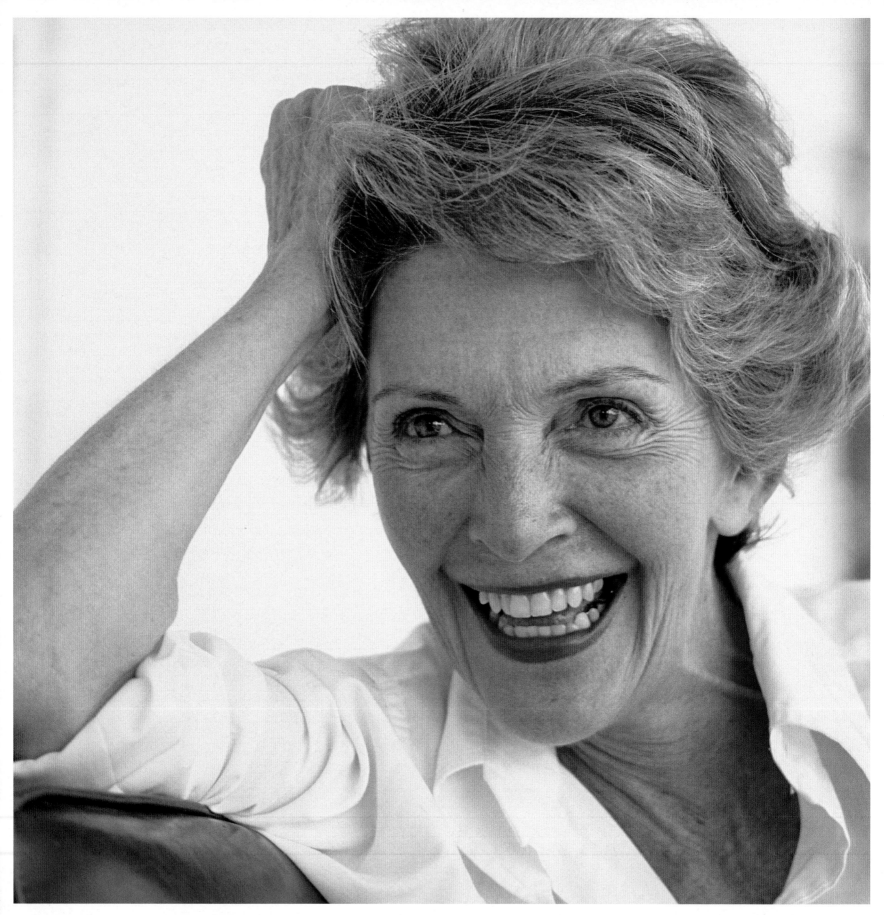

IN AUGUST 1983, I was sent by *Life* magazine to photograph Nancy at the Reagans' Rancho del Cielo in the Santa Ynez Mountains near Santa Barbara, California. The shoot was for the magazine's October cover story. Dressed in blue jeans and a shirt, Mrs. Reagan met me with a warm hello. She had complete confidence in her own style. She wasn't wearing makeup, and she had on a big straw hat to keep the sun off her face. She looked great— refreshing and natural.

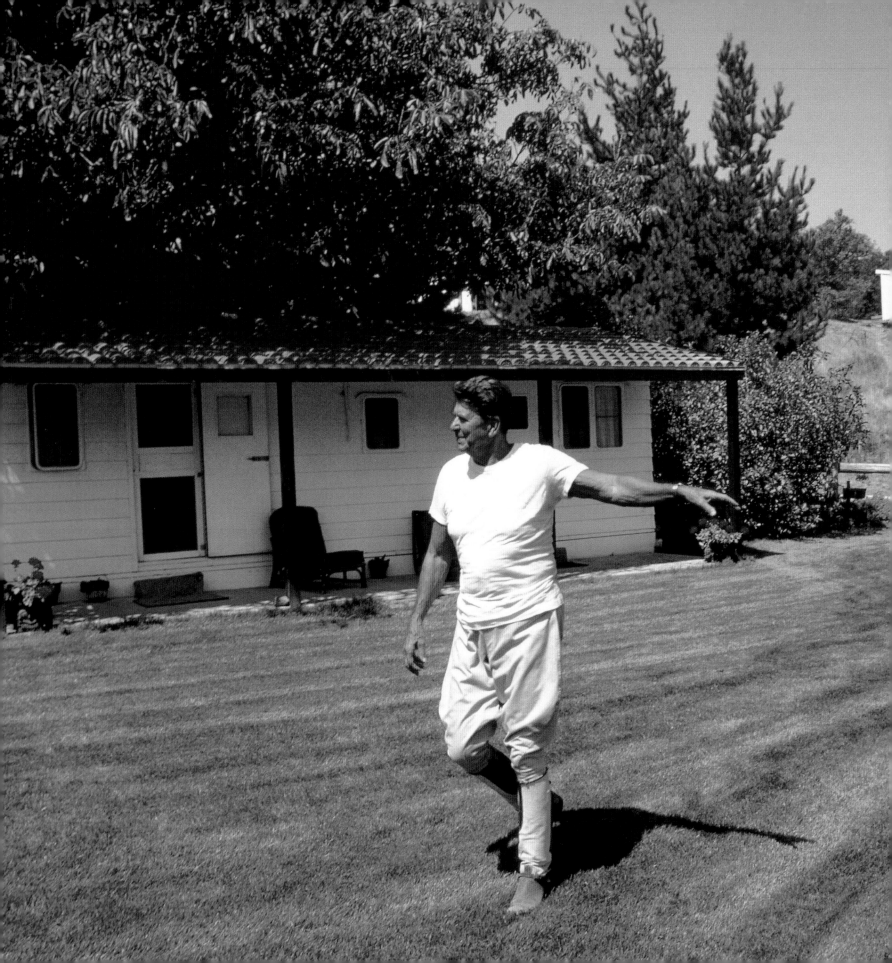

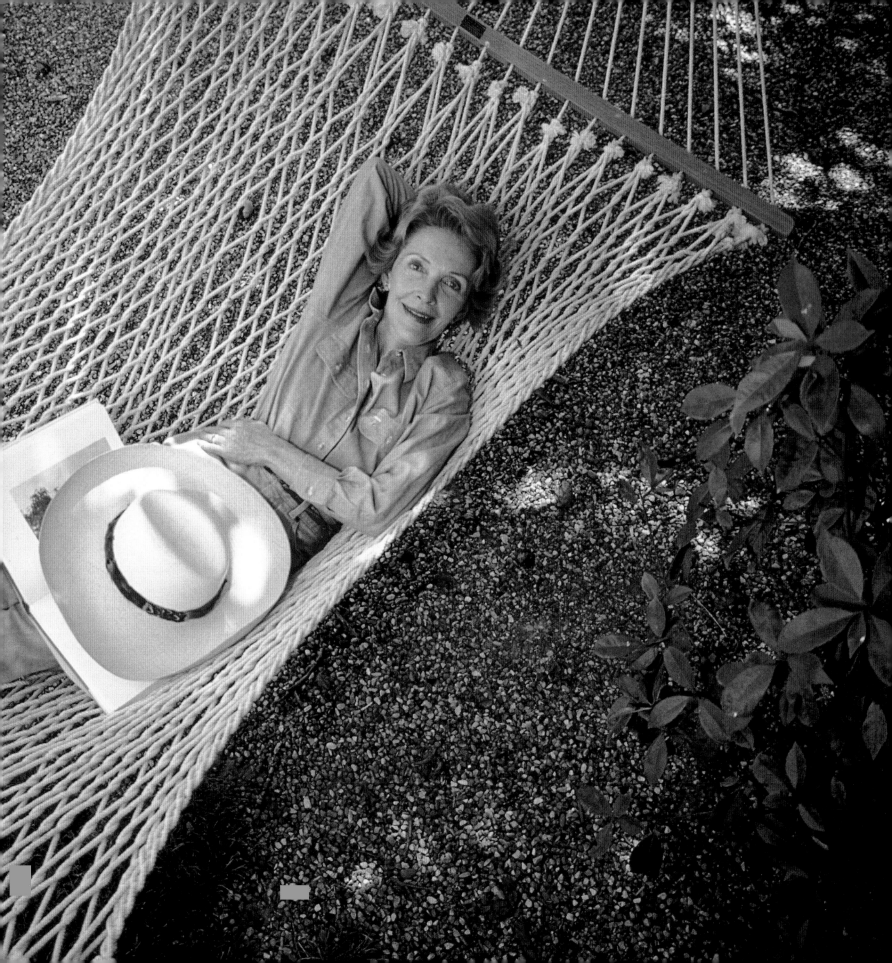

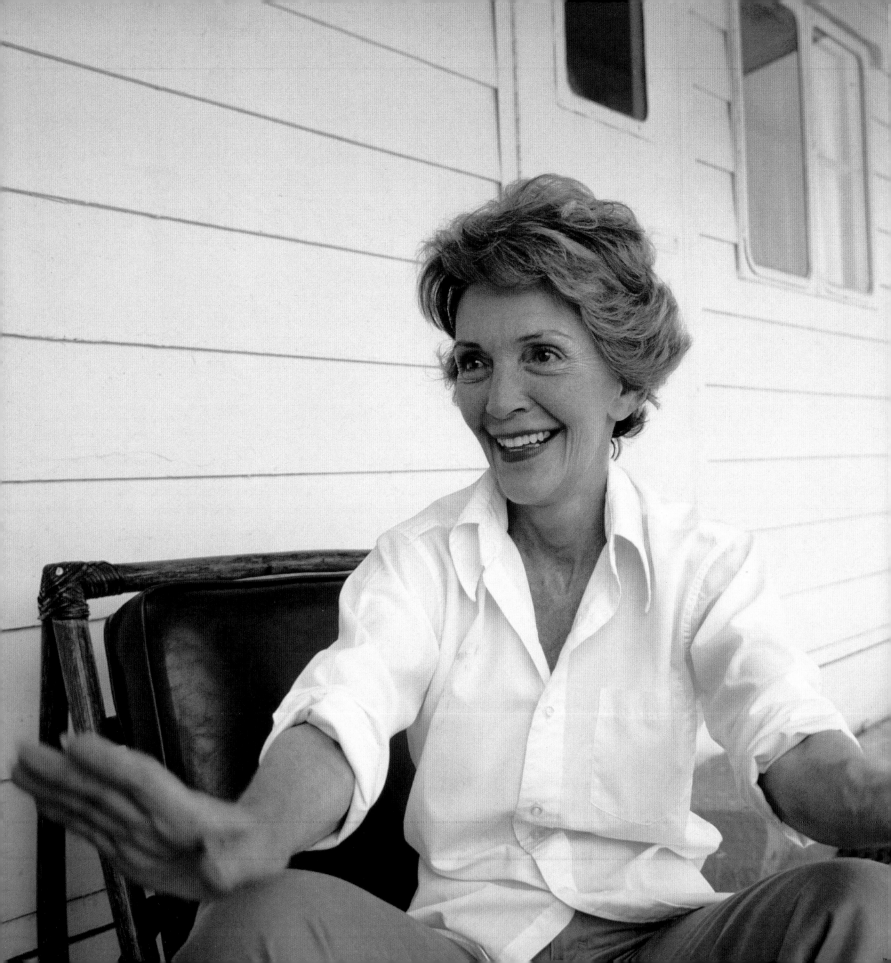

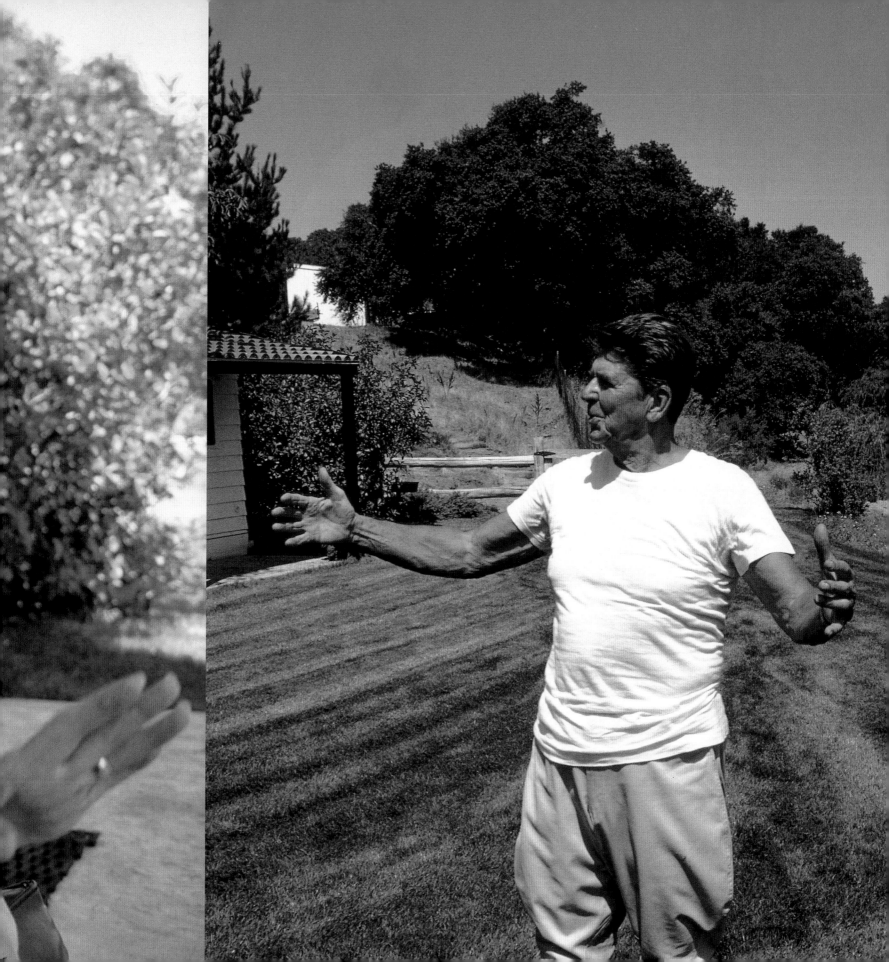

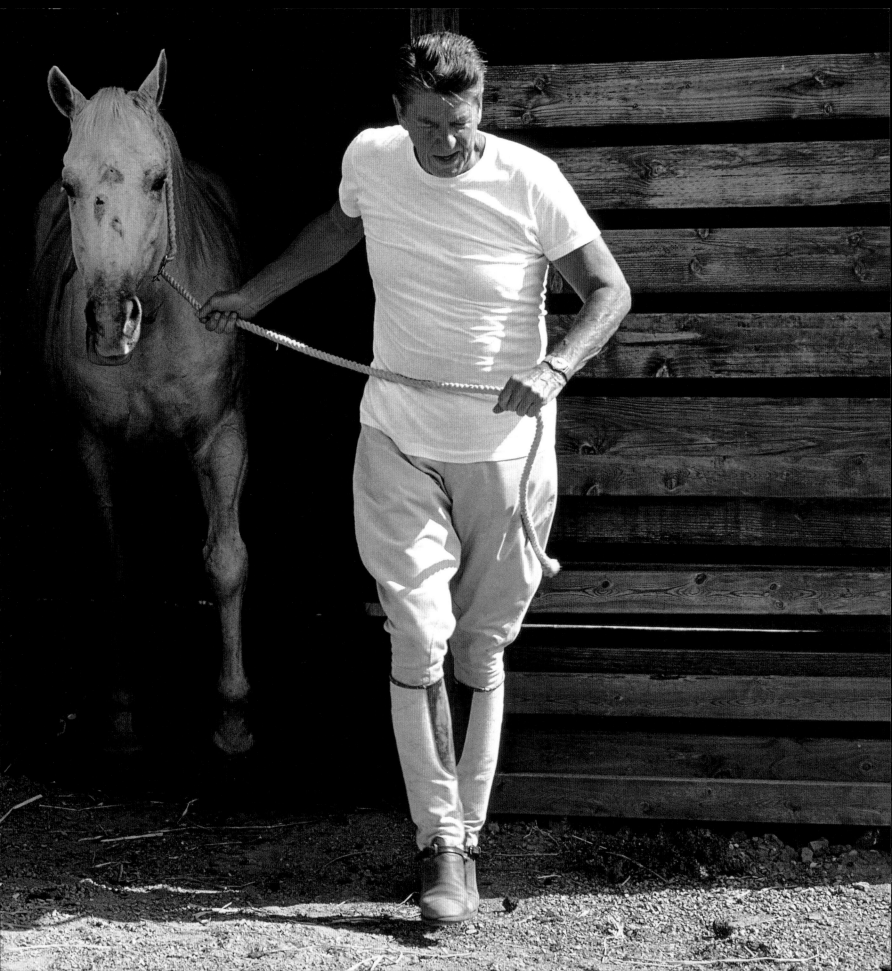

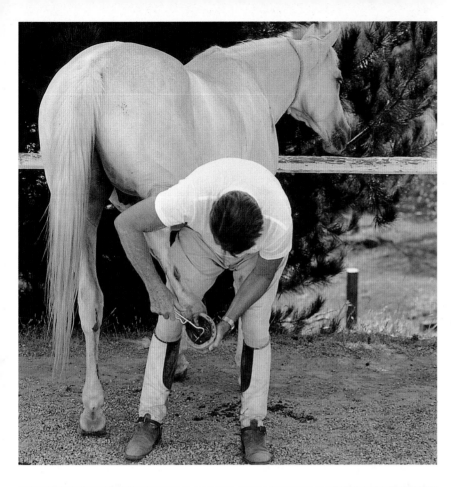
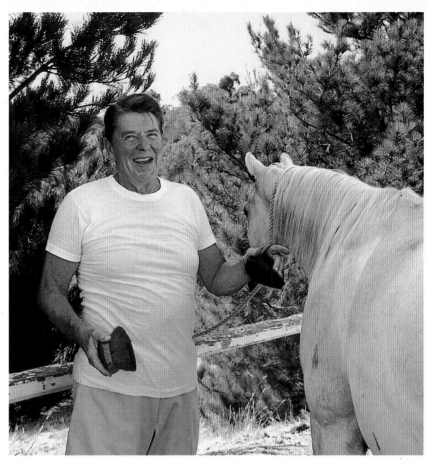
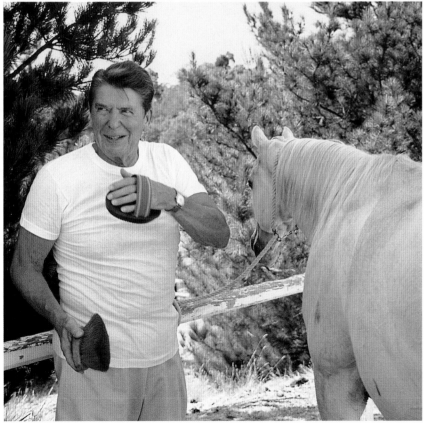
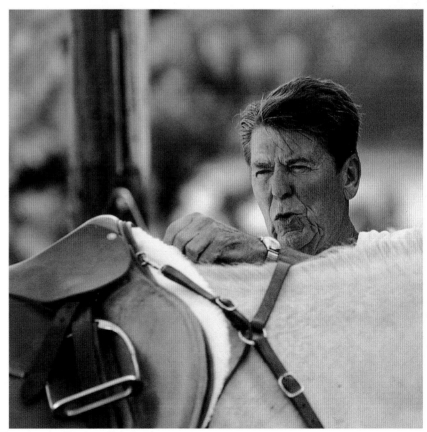

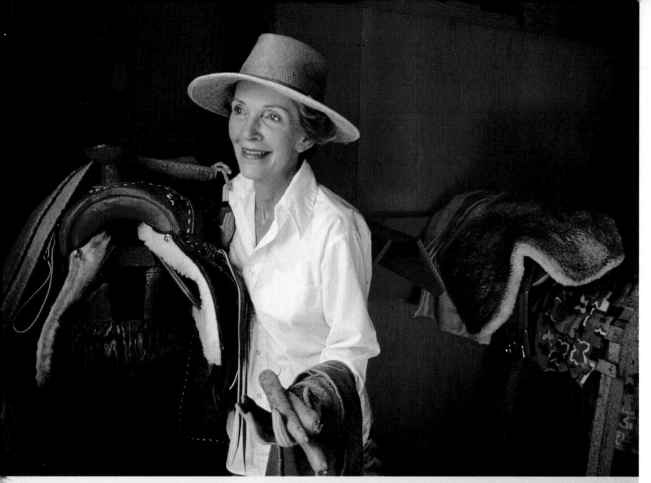

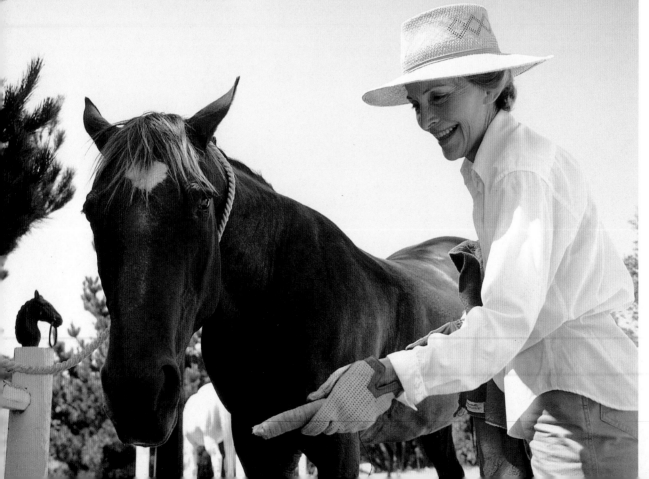

NANCY AND I HAD a pleasant day together, with the president joining us shortly after I arrived. Reagan got the horses ready for his and Nancy's daily ride. He appeared to feel more at home on horseback than she did, but she was a trooper and seemed happy because he was. He loved his horse and did the currying and saddling by himself. When the first lady needed assistance to either mount or dismount her horse, he was there to help her.

They rode for an hour way up into the hills and down again, with the president leading the way. On foot, I ran along in front of them, zigzagging back and forth over the hilly terrain. Weighed down with my cameras, I was trying to keep up, taking pictures catch-as-catch-can.

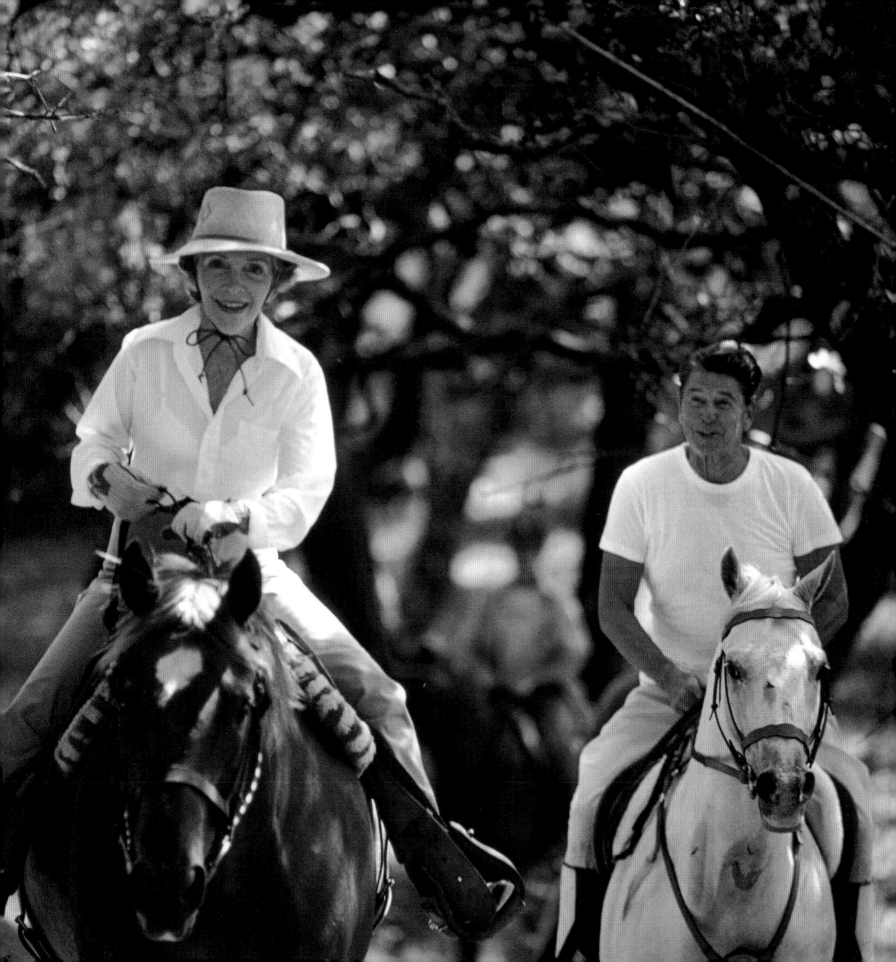

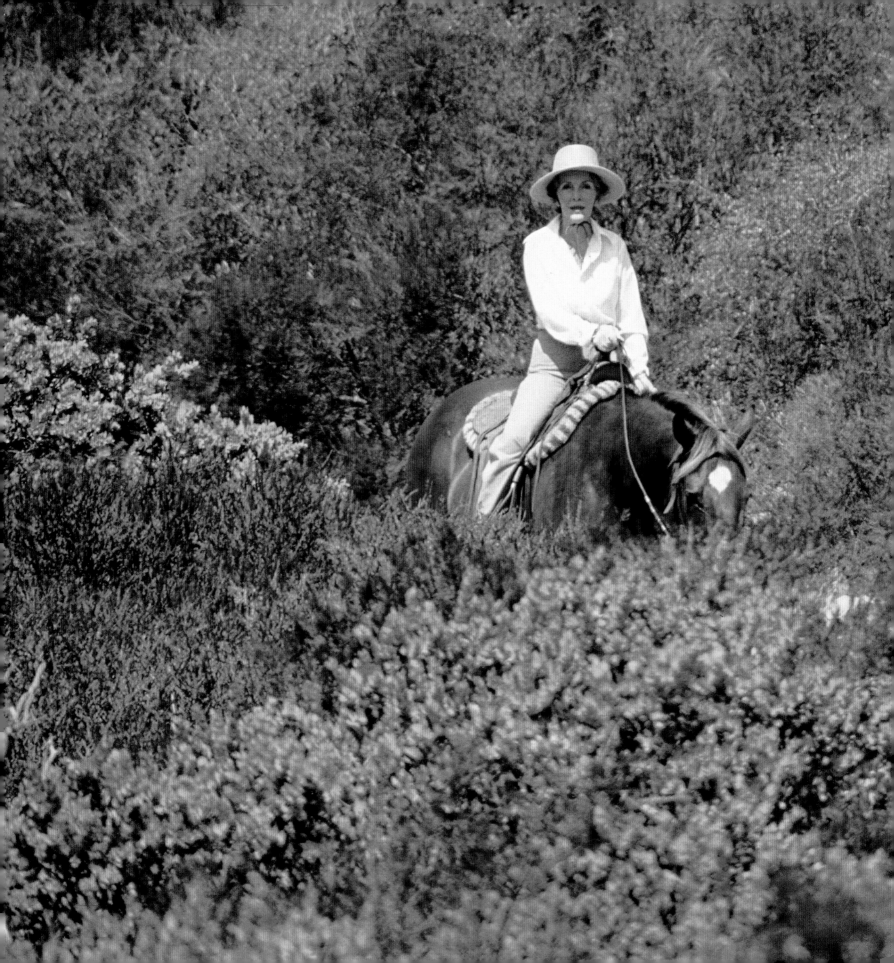

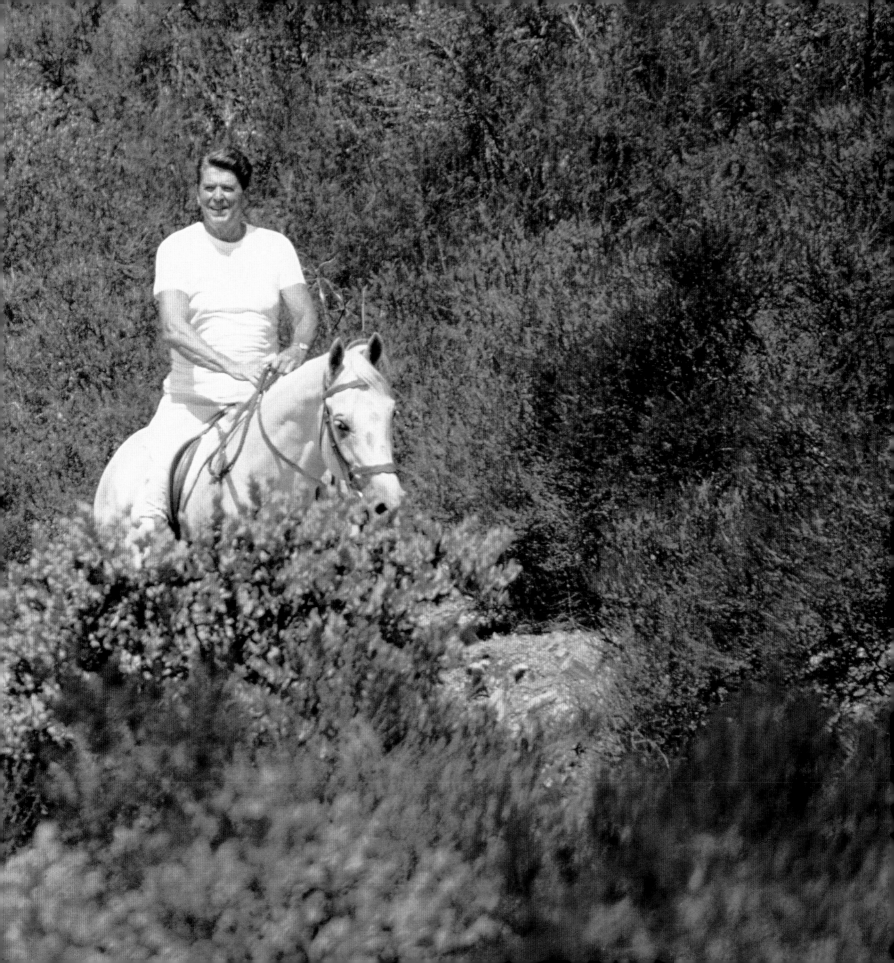

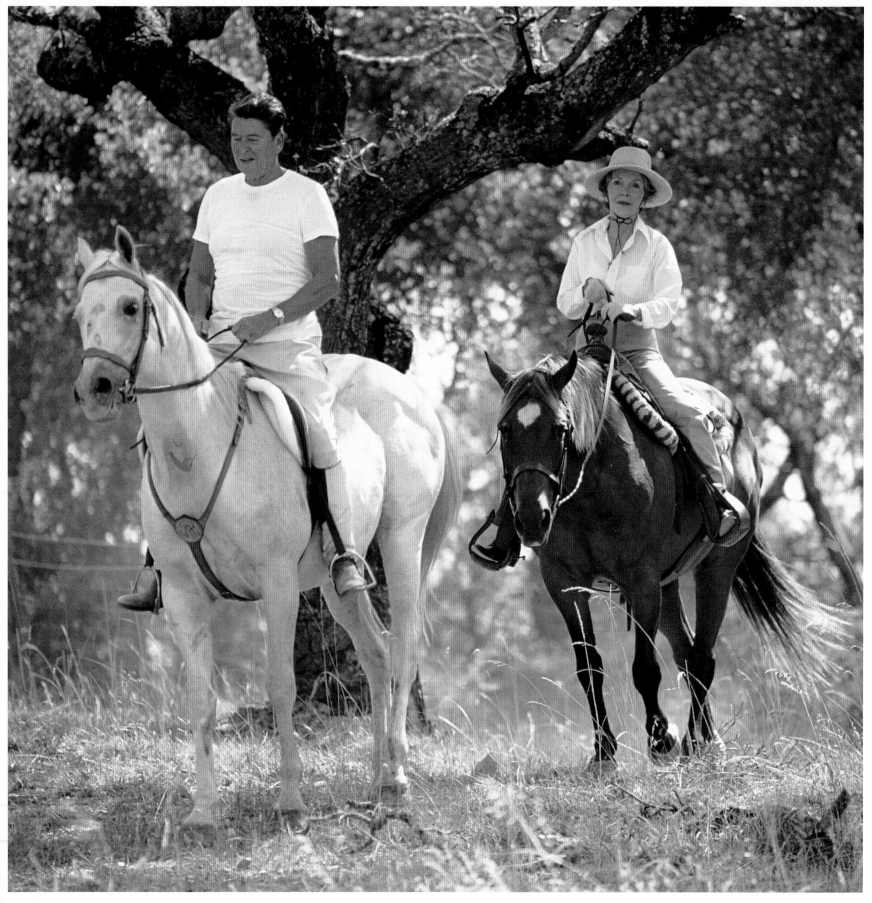

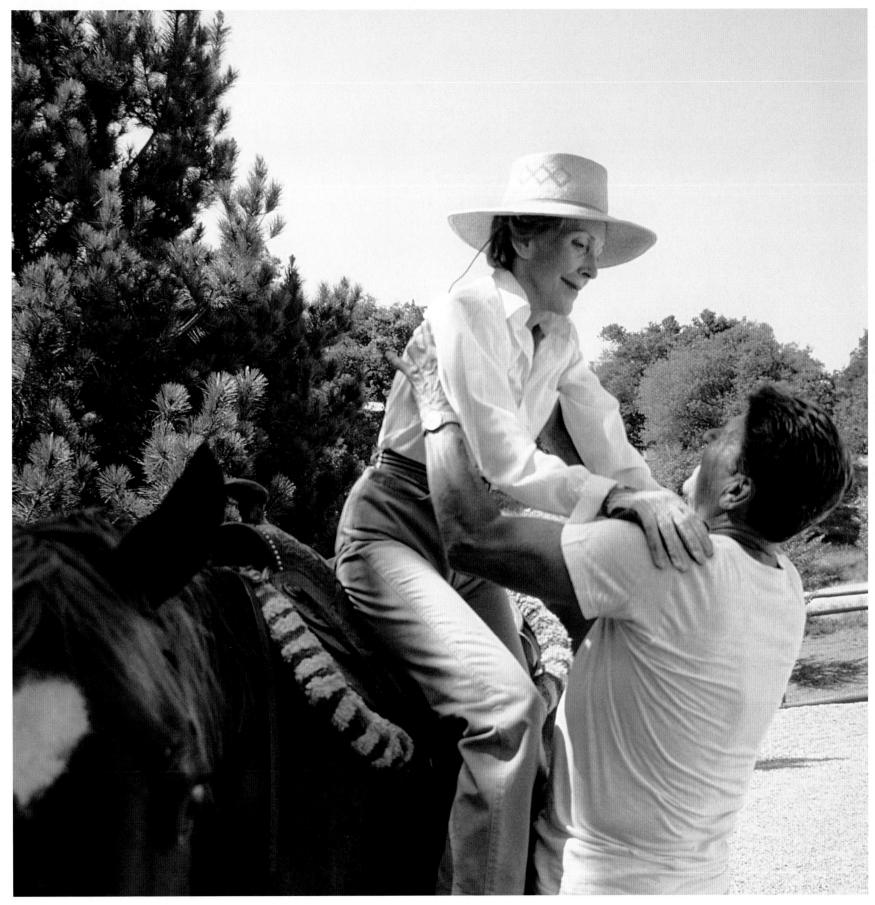

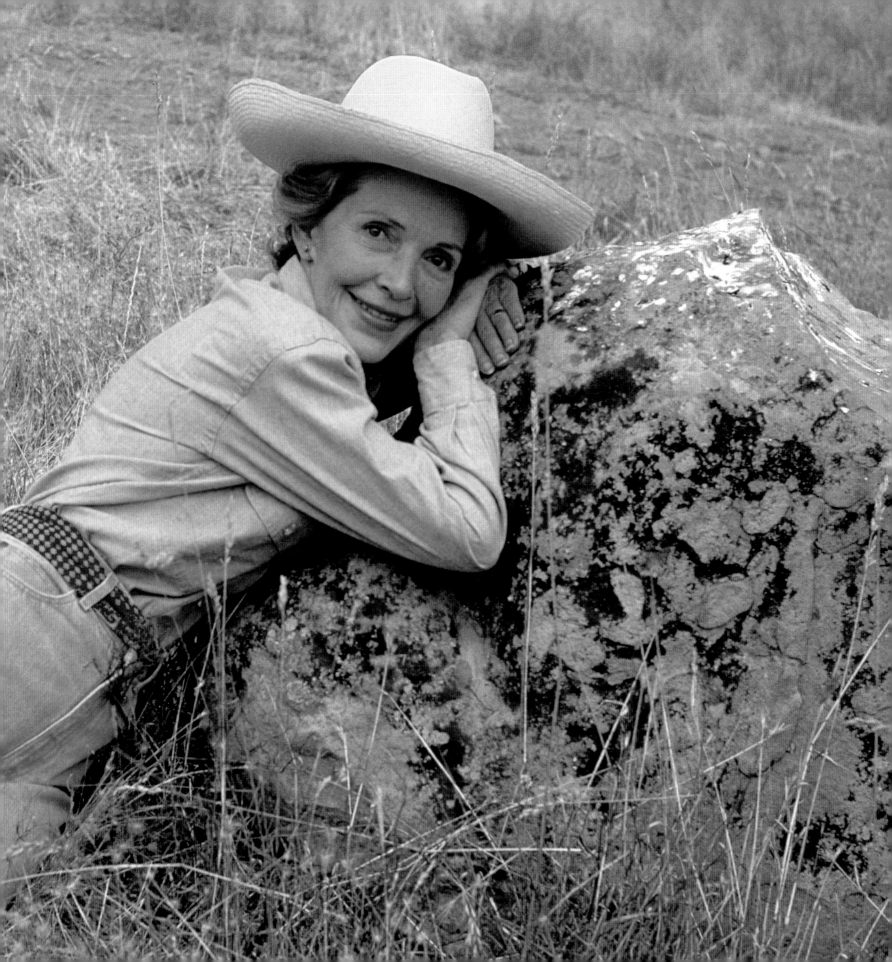

THE REAGANS HAD A SMALL ARTIFICIAL pond on the property named Lake Lucky and a canoe named *TruLuv* nearby. Mrs. Reagan told me they would often go for a spin in their canoe, which was a twenty-fifth wedding anniversary present from the president. The reason behind the gift, she explained, was that she had often told him, "When I was little I thought that when somebody asked you to marry them, they took you out in a canoe and played the ukulele while you dragged your hand in the water." We laughed at her story. The couple enjoyed themselves as the president navigated their journey around the lake, and Nancy dangled her hand in the water.

The Reagans could not have been more congenial and easy to work with. Their previous careers in front of motion-picture cameras made them the ideal subjects for a photographer. However, I never felt that they were performing for me. I sensed a down-to-earth naturalness about them that was not rehearsed. They were relishing their life together.

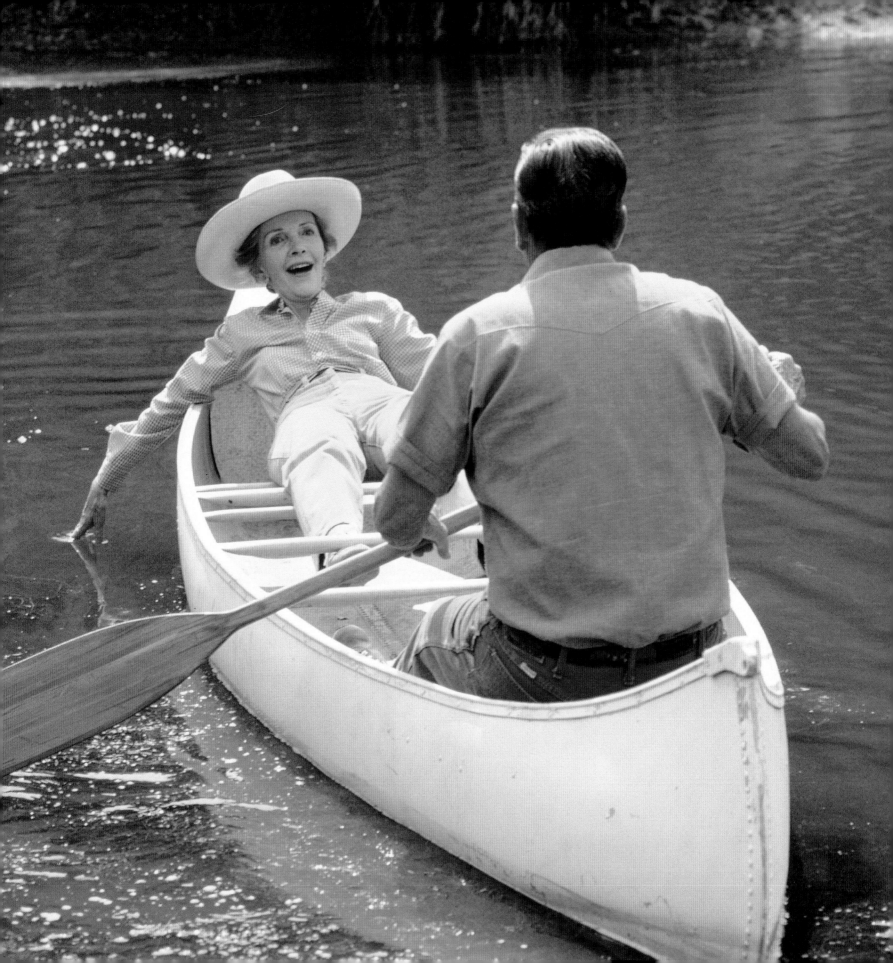

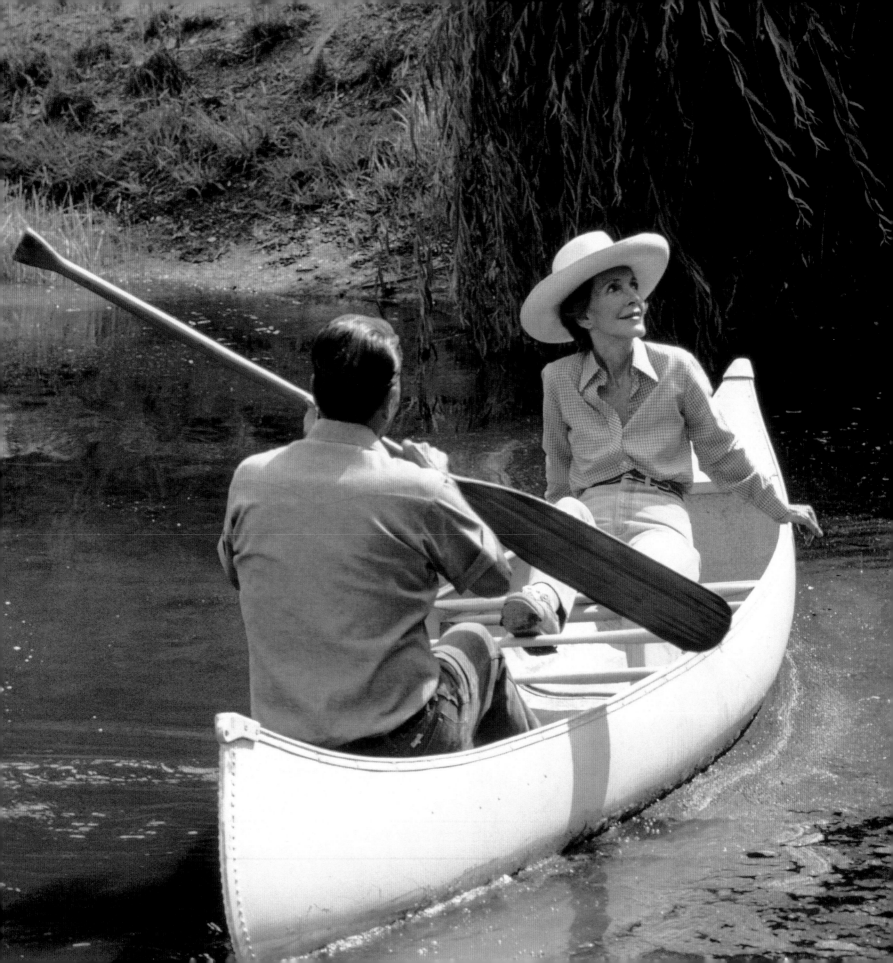

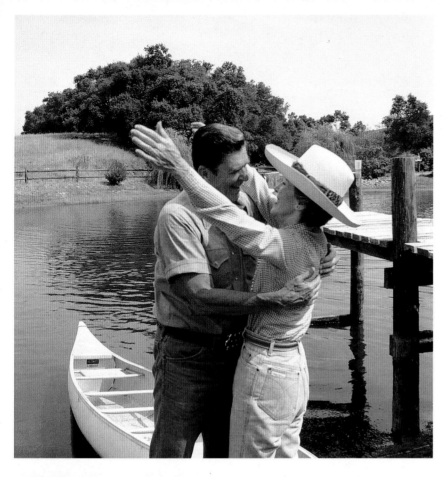
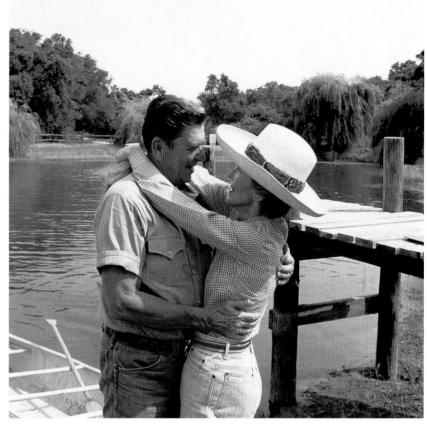
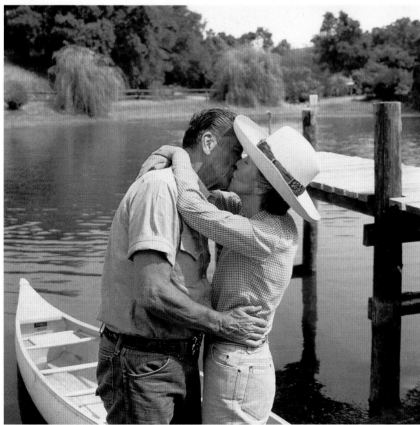
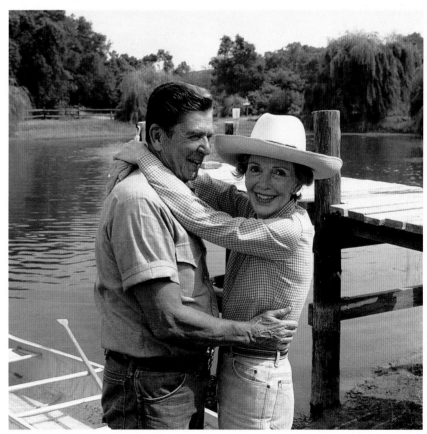

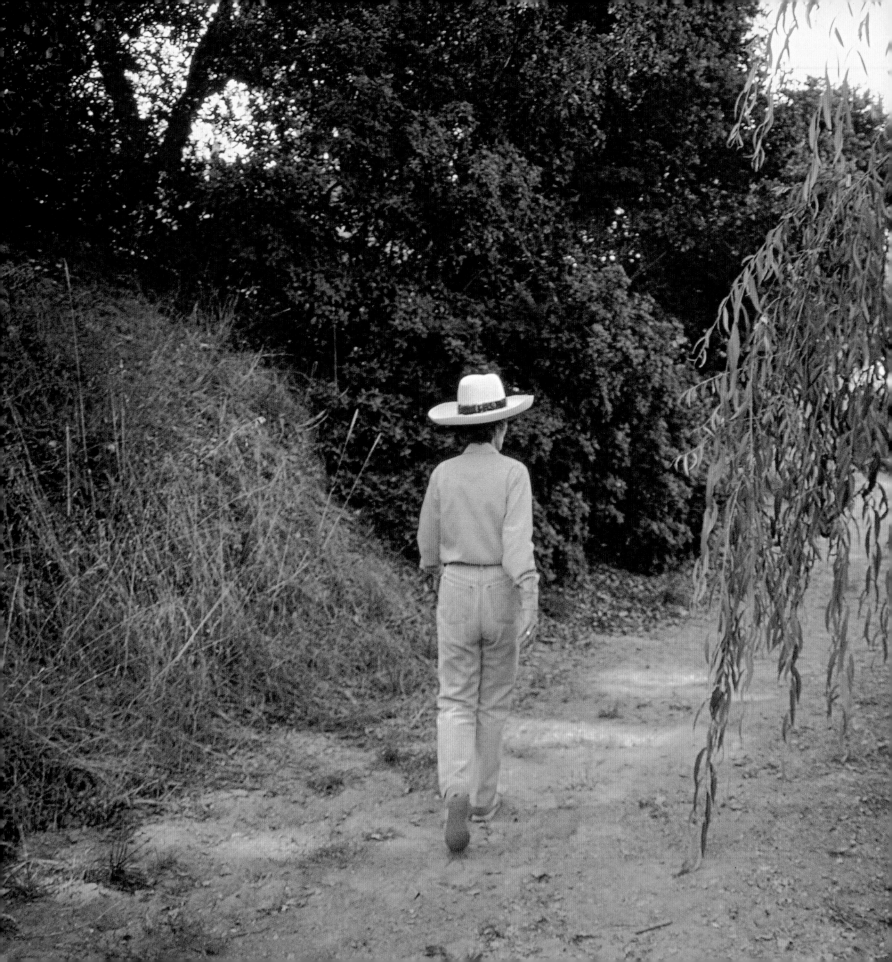

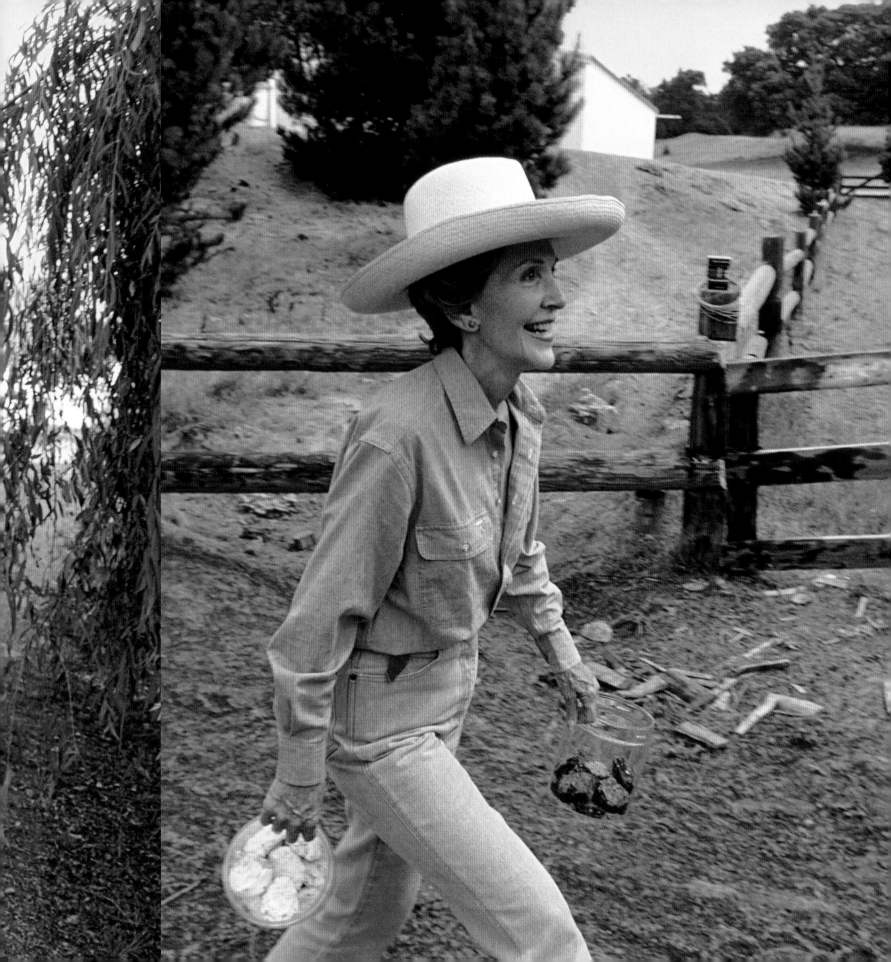

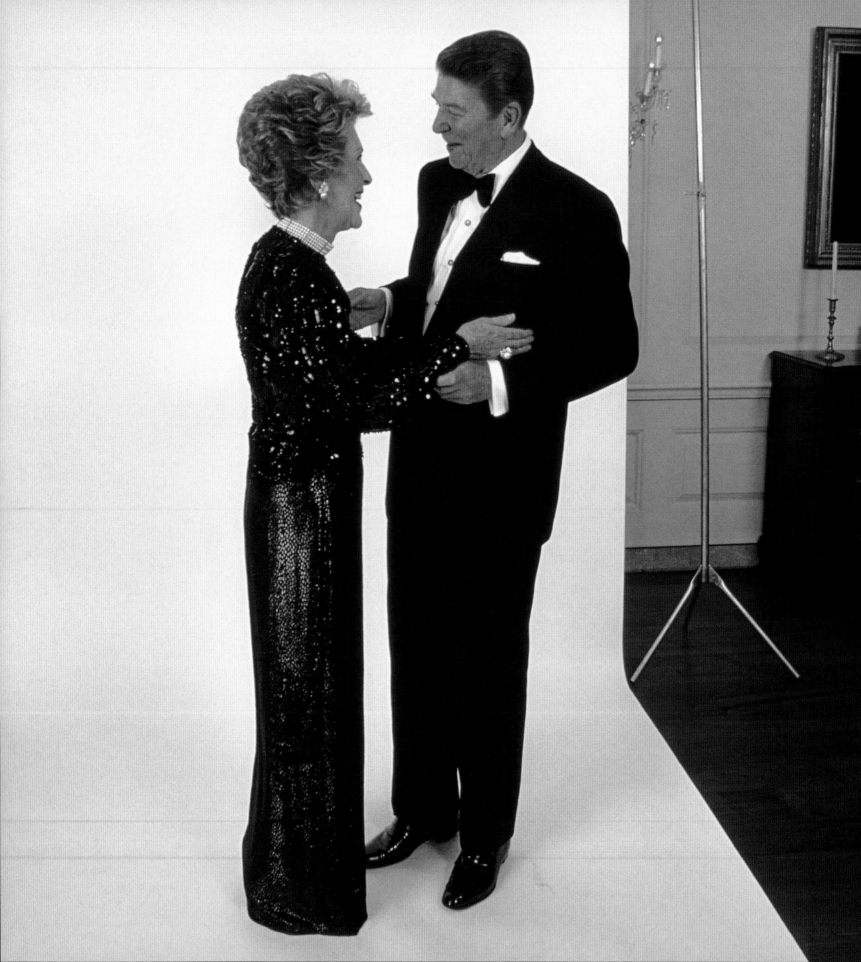

IN MARCH 1985 *VANITY FAIR* asked me to photograph the Reagans for the cover story of the June issue, so off I went to the White House. The Reagans' schedule was very tight, and their press secretary agreed to give me five minutes just before a state dinner. An aide escorted me to the Map Room and asked me to wait. Unbeknownst to any of the staff, I quickly created a studio with white seamless paper and strobe lighting.

When the president and Mrs. Reagan entered—he, stately in his tux, she, dressed in a bedazzling Galanos gown—I switched on some music. I had brought a tape of Frank Sinatra singing "Nancy with the Laughing Face." They immediately smiled. When I asked them to dance, she grabbed his hand and put it around her waist and they began.

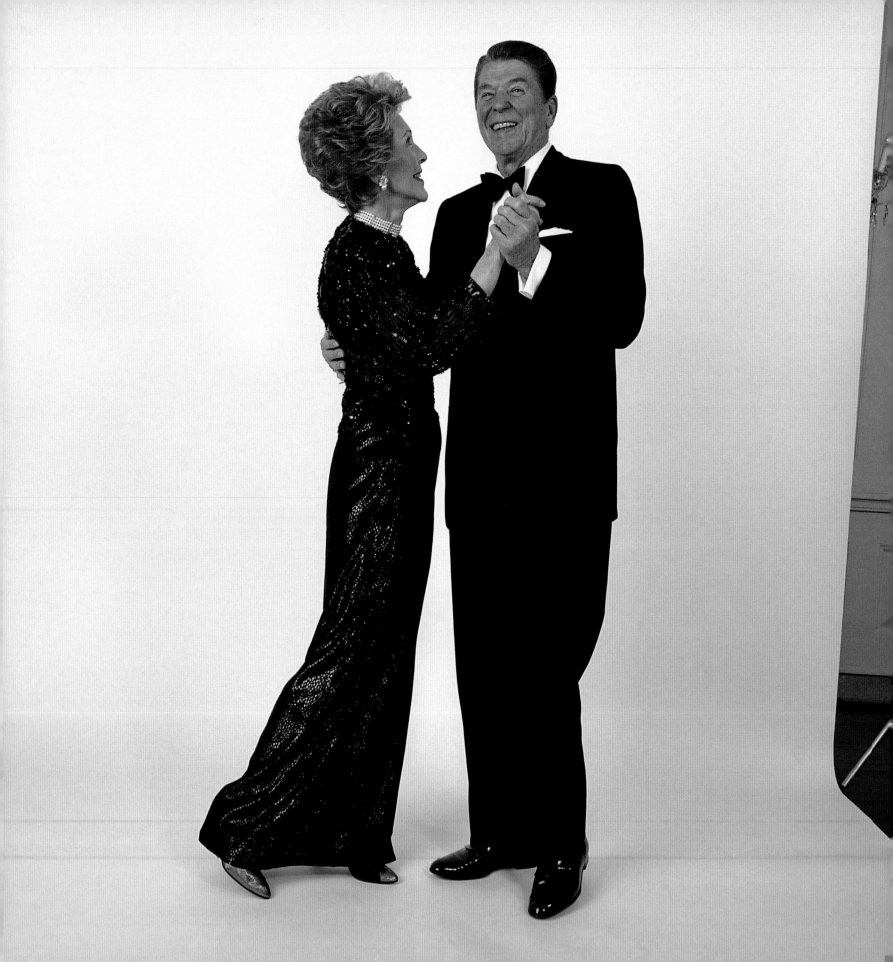

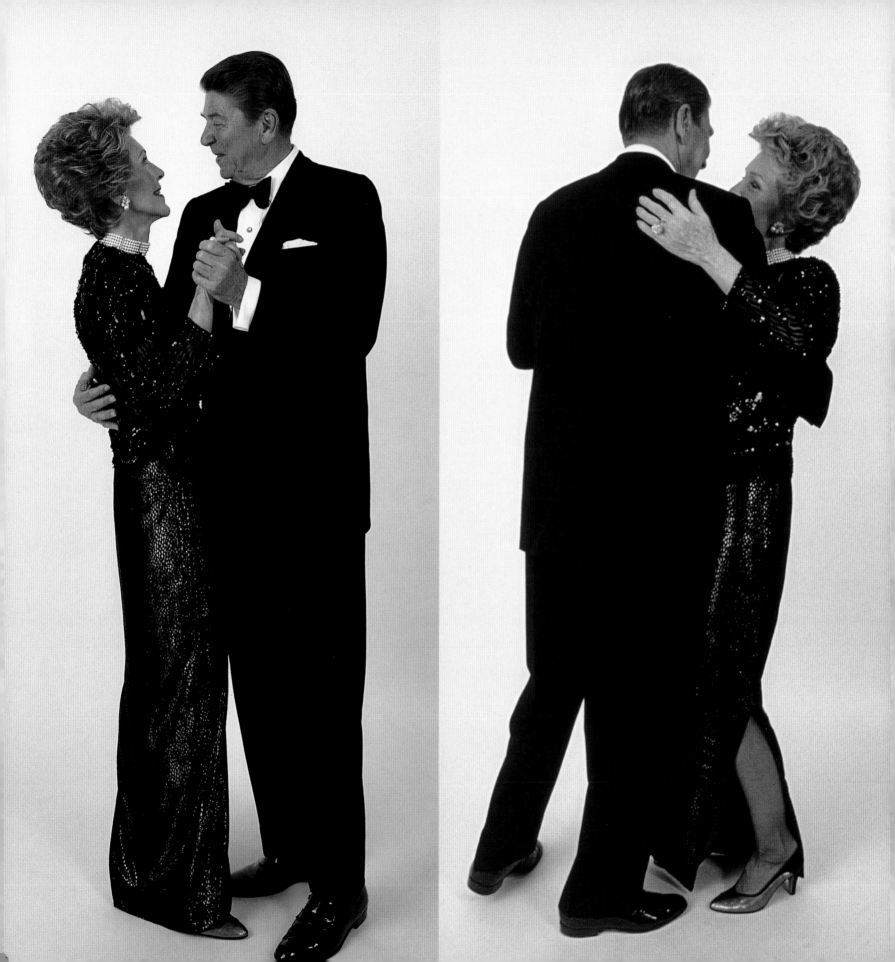

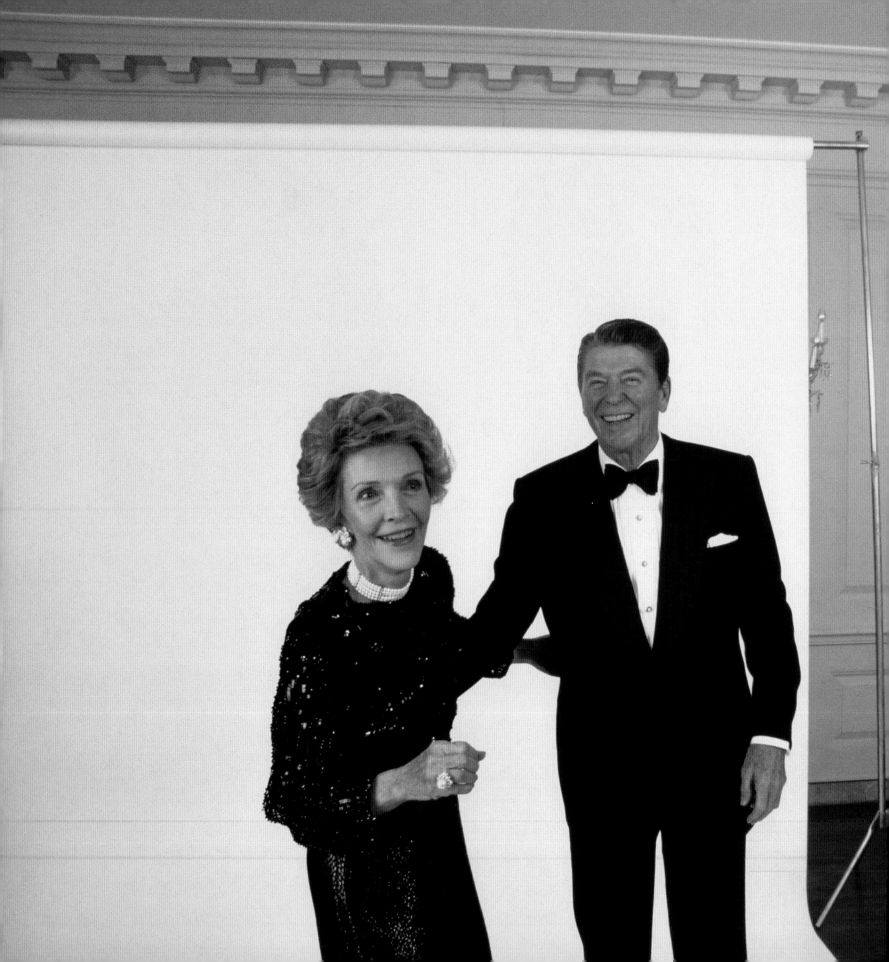

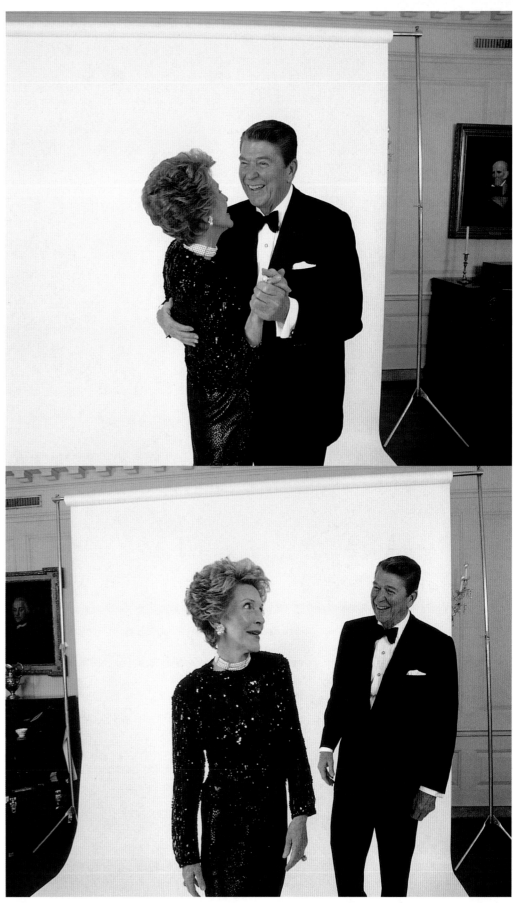

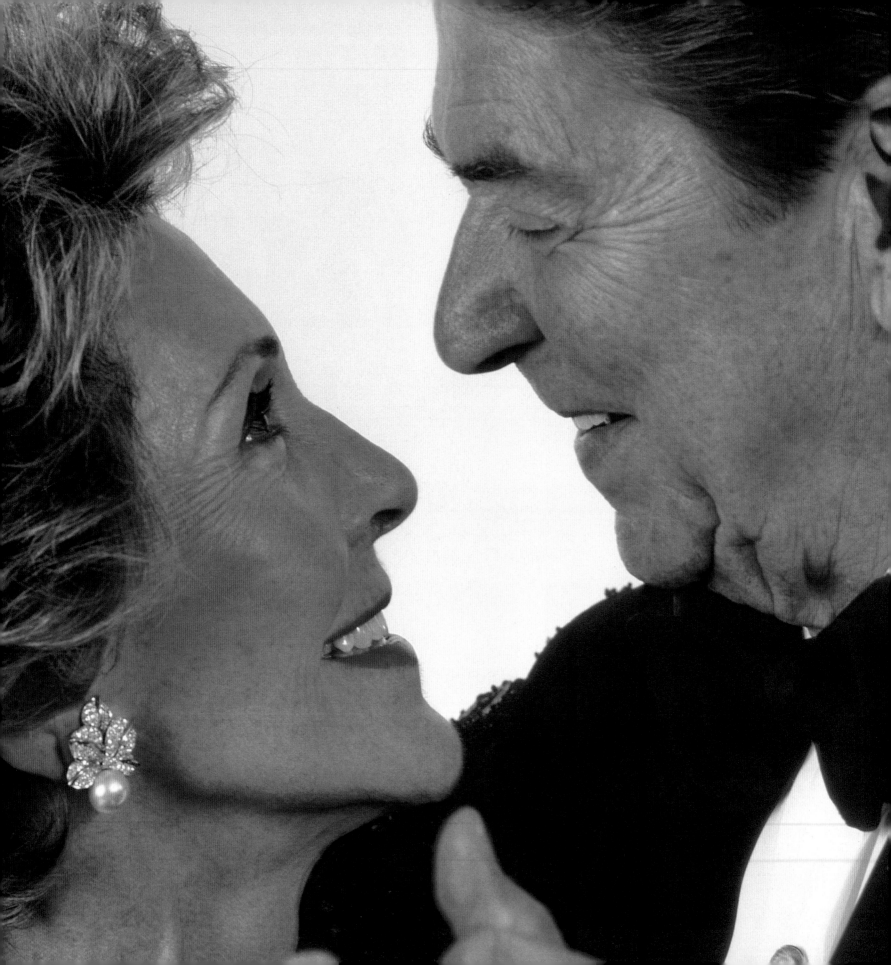

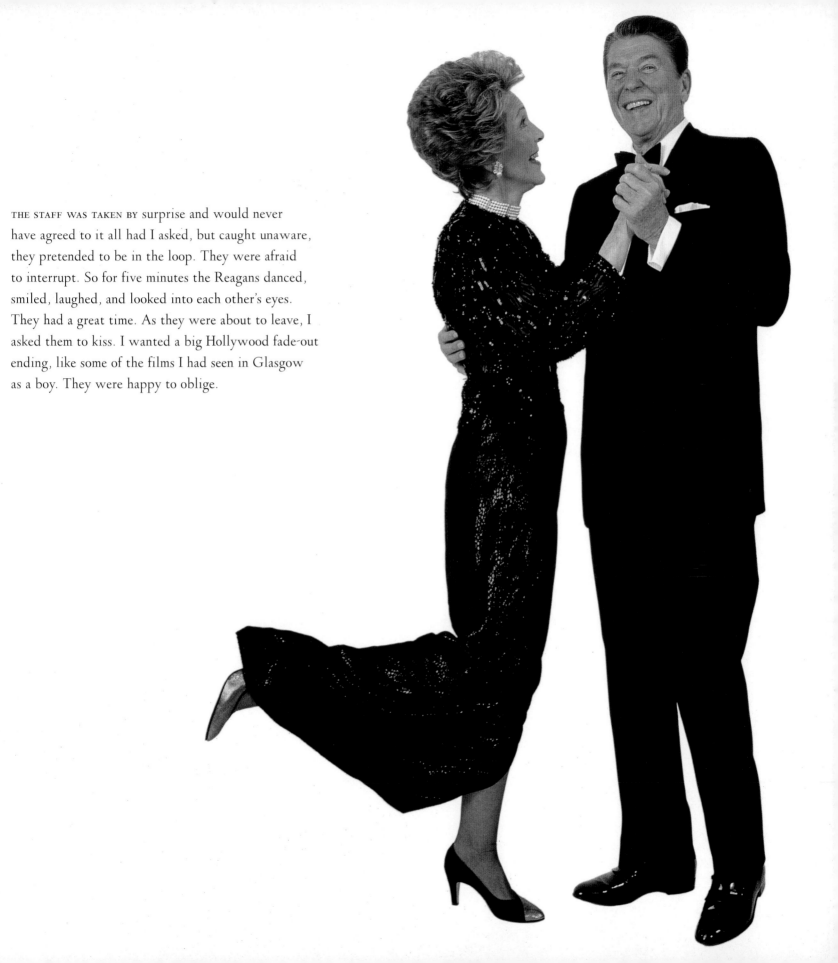

THE STAFF WAS TAKEN BY surprise and would never
have agreed to it all had I asked, but caught unaware,
they pretended to be in the loop. They were afraid
to interrupt. So for five minutes the Reagans danced,
smiled, laughed, and looked into each other's eyes.
They had a great time. As they were about to leave, I
asked them to kiss. I wanted a big Hollywood fade-out
ending, like some of the films I had seen in Glasgow
as a boy. They were happy to oblige.

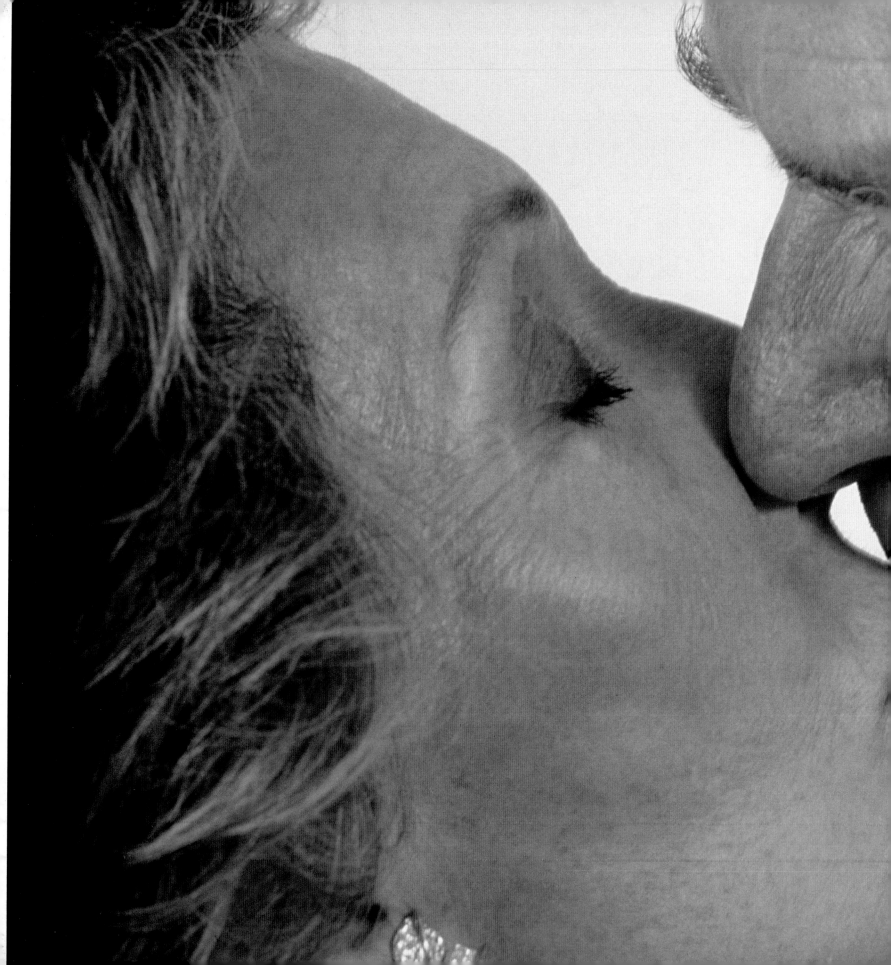

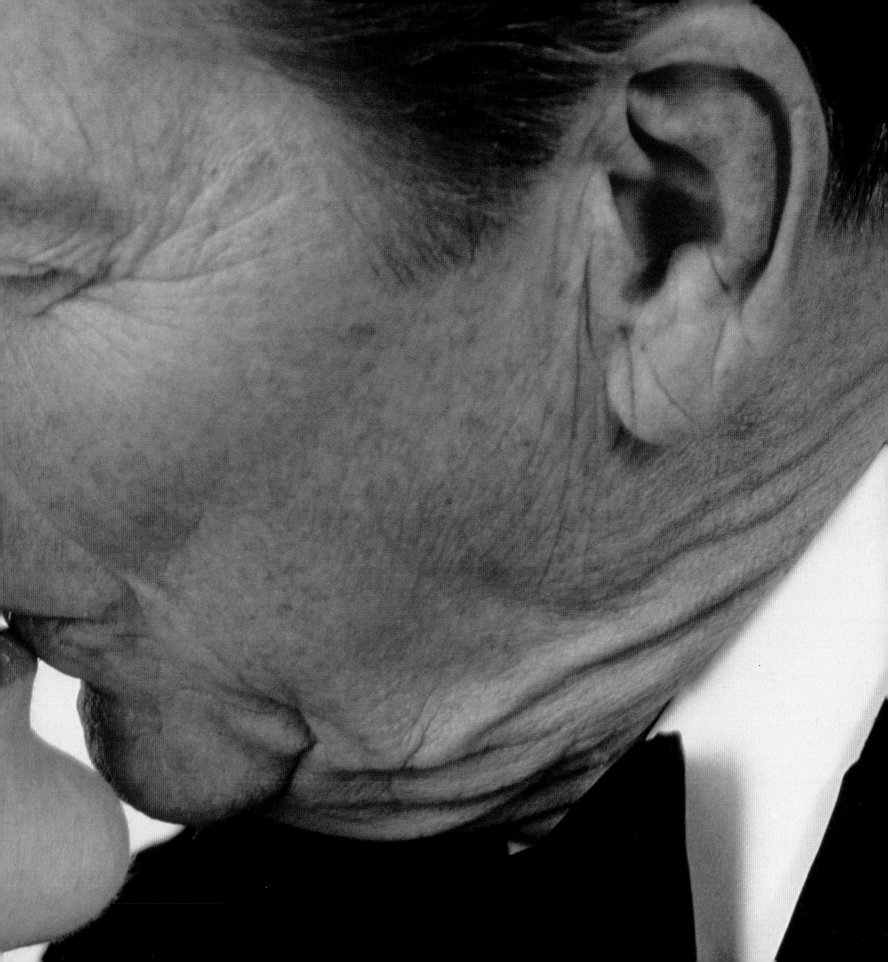

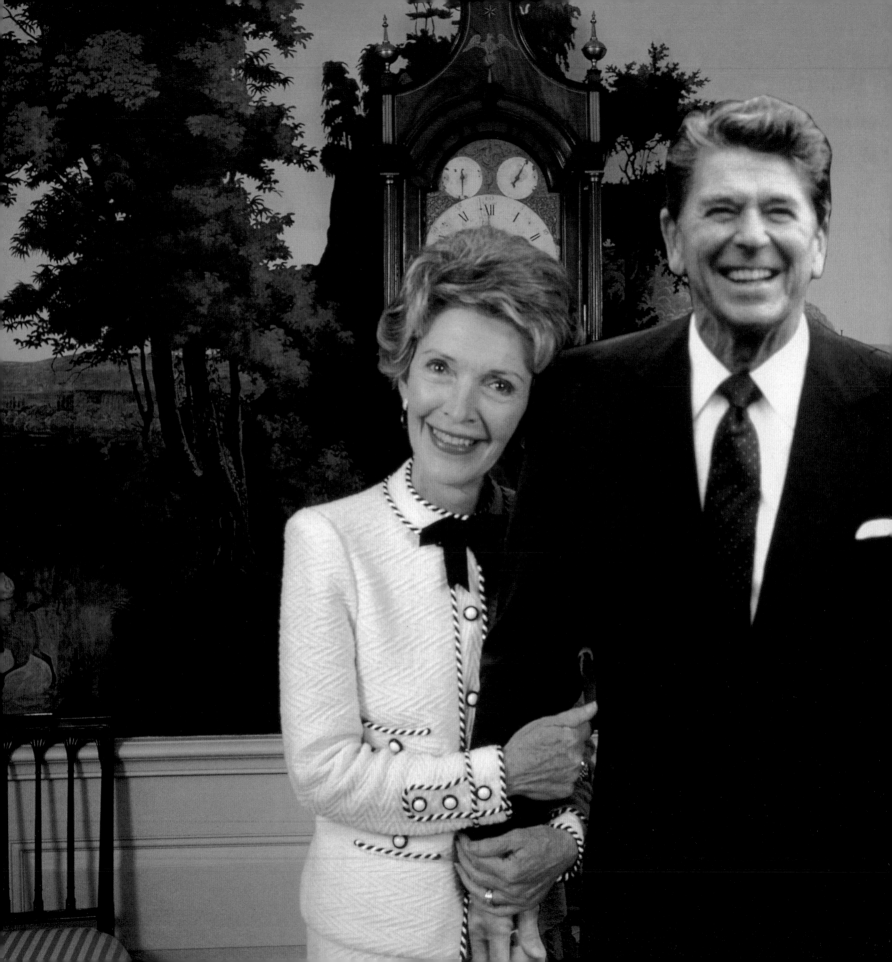

NANCY REAGAN HAS A KEEN sense of humor. A case in point: In June 1985, I returned to Washington, D.C. because there were a couple of men with a life-size cardboard cutout of the president right outside the front gates of the White House. They were charging tourists a fee to pose with the cardboard image for an instant photo. The Reagans knew about it and found it amusing. When I arrived, I photographed the men outside and then asked Mrs. Reagan if she would pose with the cutout. She actually thought it was a very funny idea. We brought "the president" inside and she leaned her head on "his" shoulder. It was incredible, because at first glance the cutout looked so real. I tried to get the real president to pop his head into the room, but he was in a meeting. Nancy was a terrific sport about the whole thing.

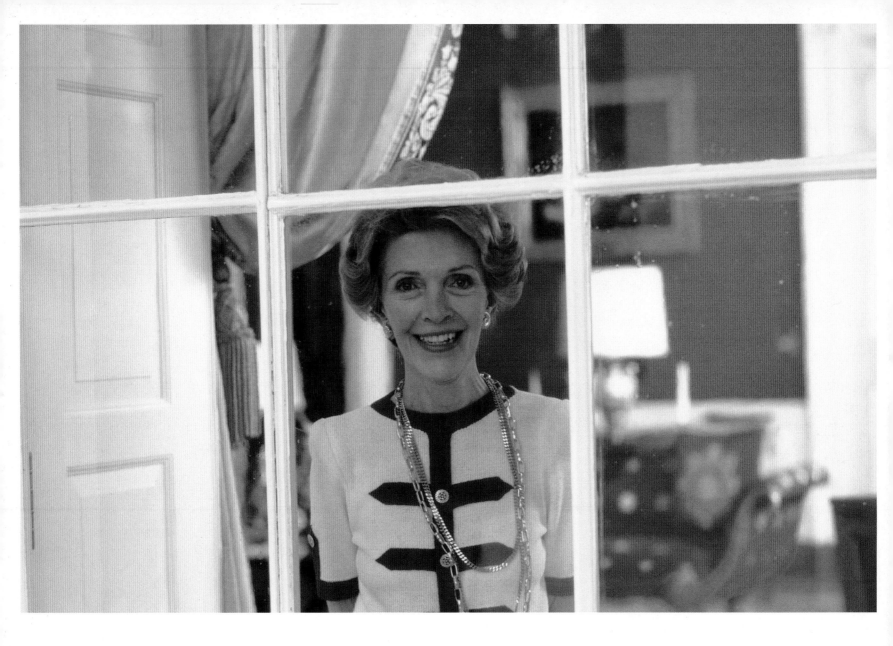

IN 1986 *LIFE* ASKED ME to photograph each of the former first ladies as
well as Mrs. Reagan, who was living in the White House at the time.
As gracious as ever, she entered the room in a stunning, long Galanos
gown and stopped at the side of the table. Everything seemed right, the
red dress in the Red Room, her elegant pose. She told me the Red Room
was one of her favorite rooms in the White House. Two years earlier, for
the French magazine *Madame Figaro*, I photographed her in the same room
in a less formal manner, stepping outside onto the balcony and shooting
through the window, which seemed to amuse her.

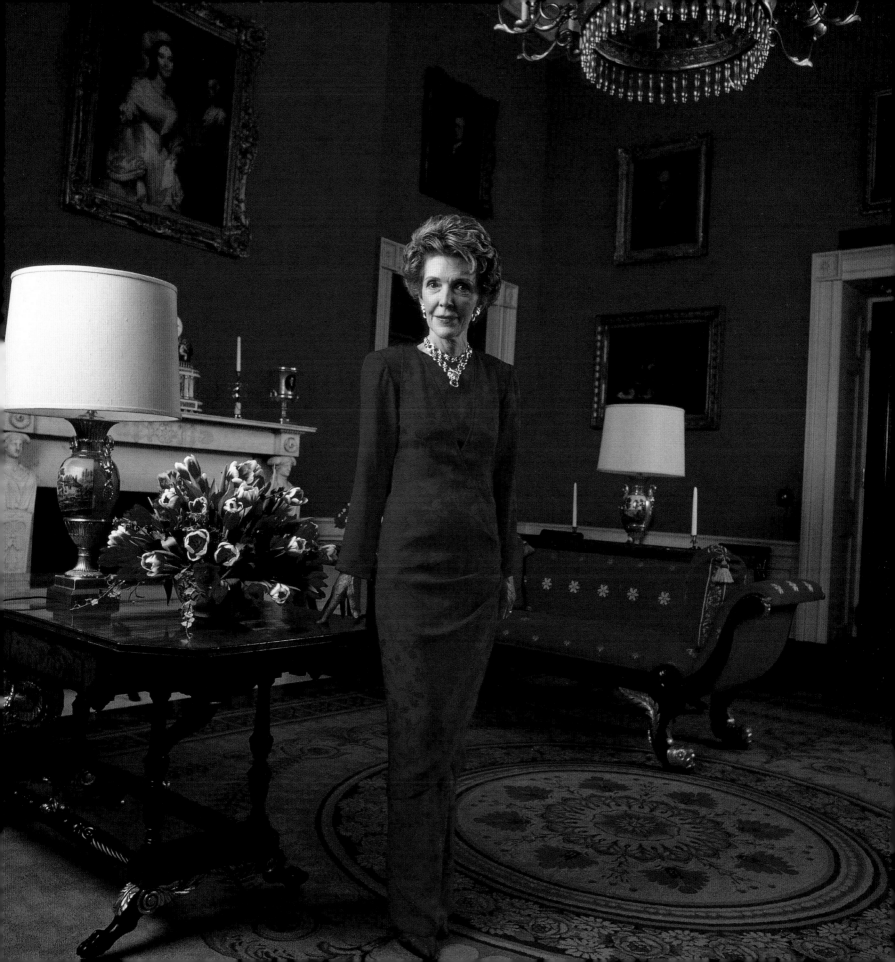

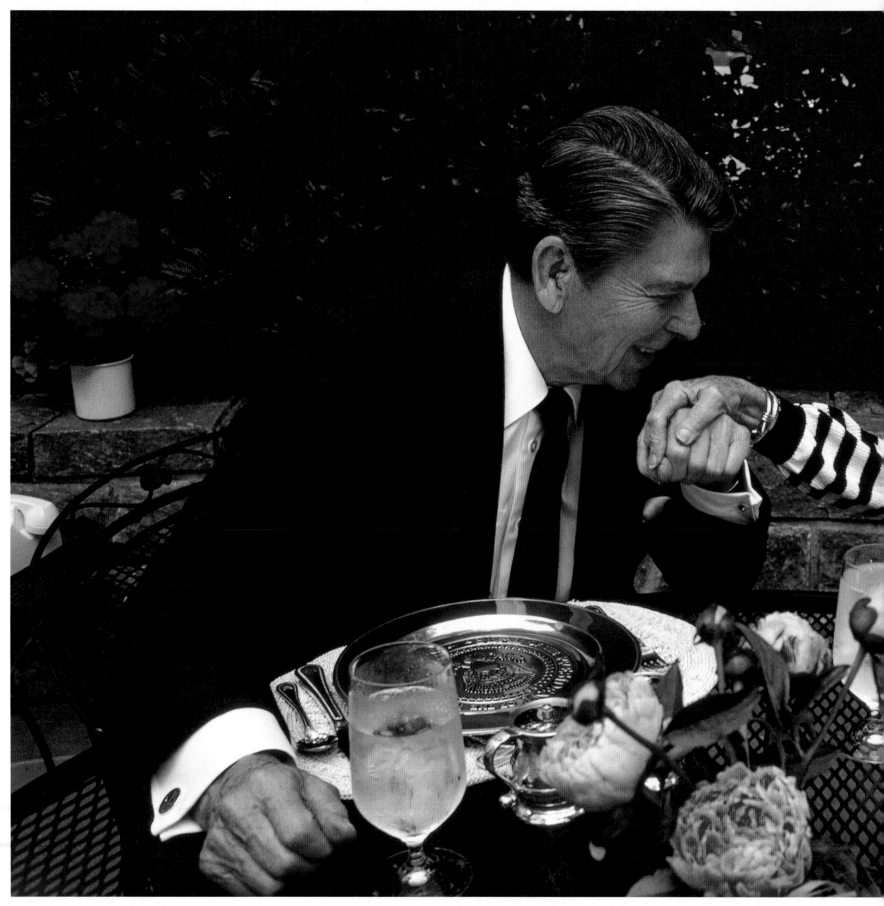

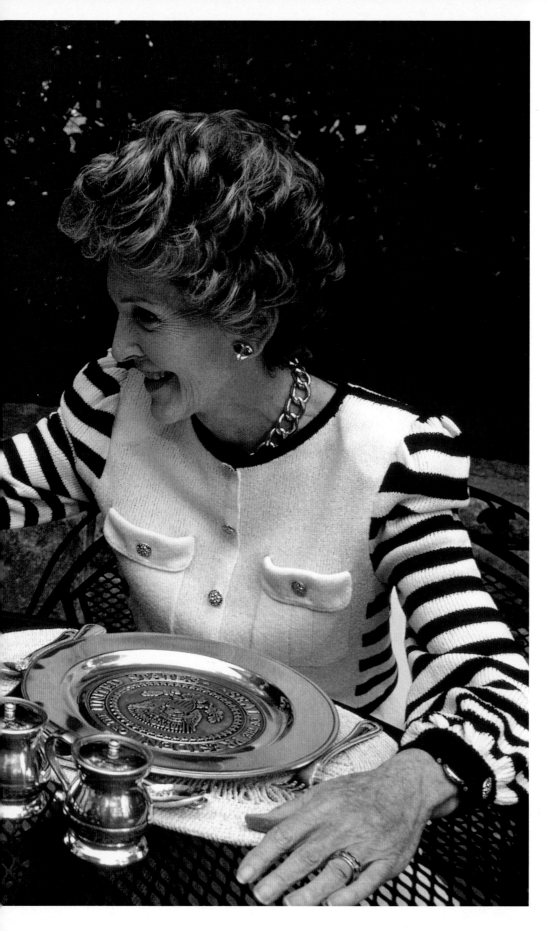

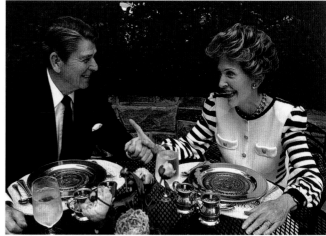

IN NOVEMBER 1986 I went to the Rose Garden at the White House to photograph the president and first lady for *Life* magazine's fiftieth anniversary issue. The Reagans appeared that day in fine spirits, jovial in fact. Their relationship seemed fresh and new yet at the same time comfortable, possessing a familiarity only found in couples who have long known each other's secrets.

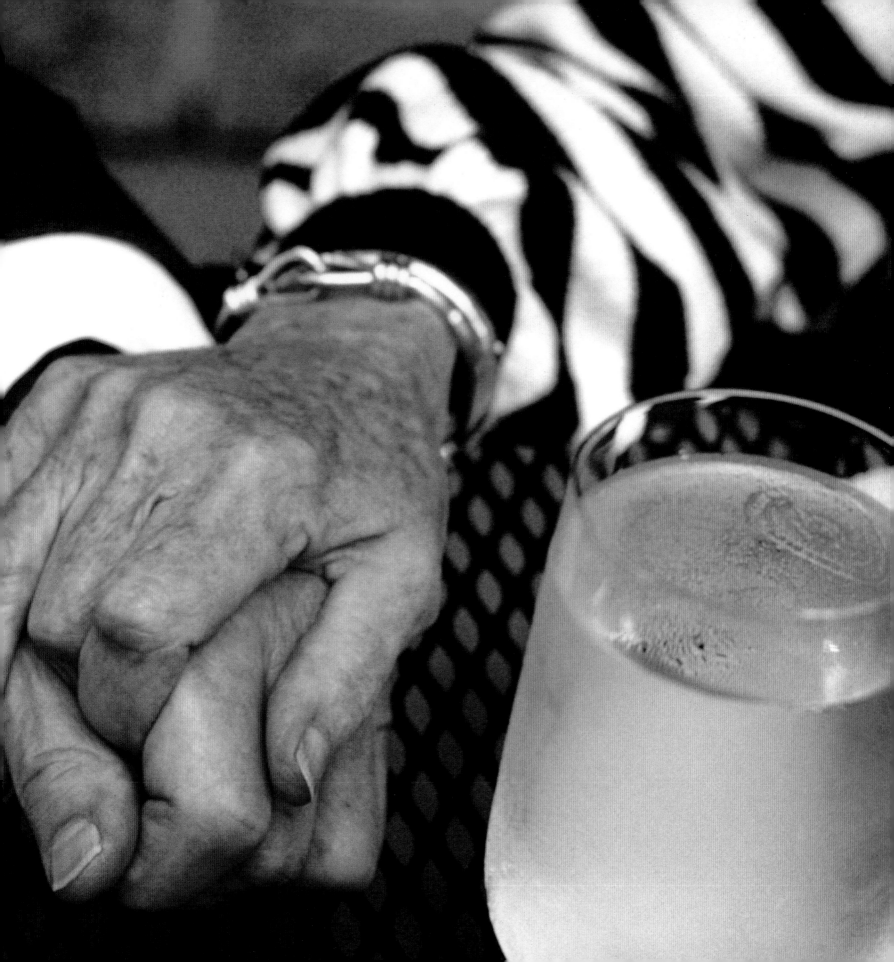

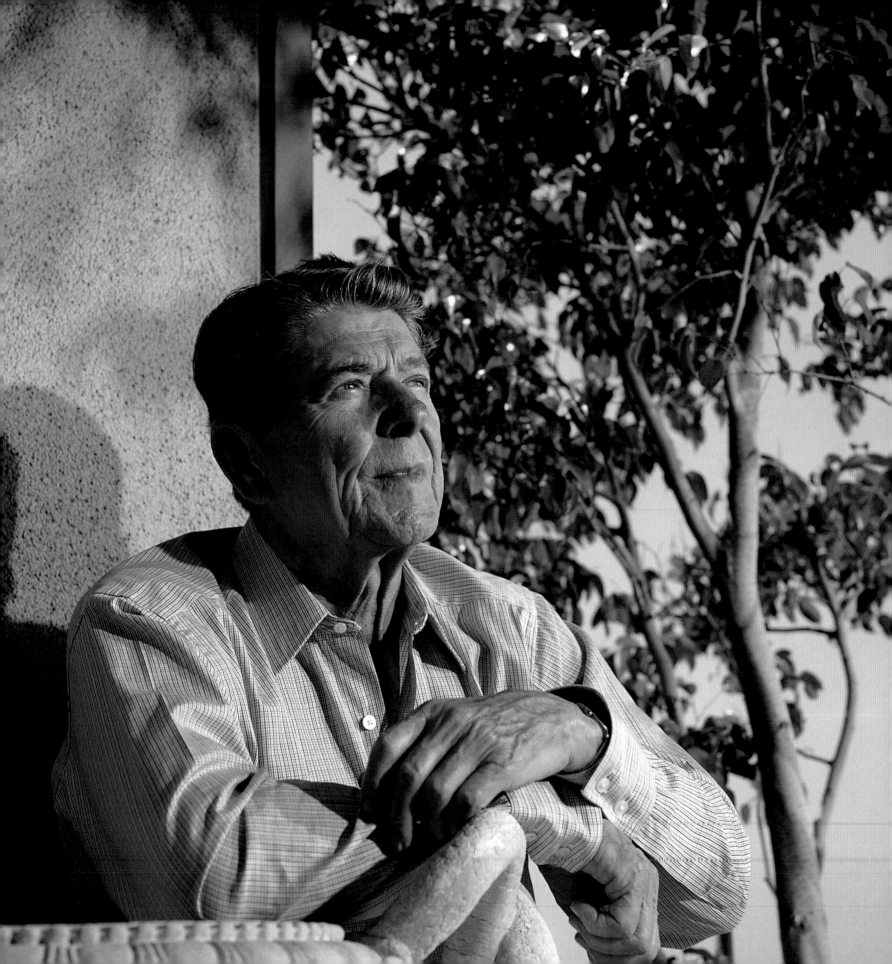

IN 1987 LIFE ASKED me to photograph two former presidents, Gerald Ford and Jimmy Carter, as well as President Reagan. The president was photographed at his West Coast office on the Avenue of the Stars in Century City. The name of the street was appropriate because he was more popular than ever. Looking down from the balcony outside his office high above the city, Reagan motioned toward the Twentieth Century Fox lot below, pointing to a large sound stage where he told me he had worked during his early career in Hollywood.

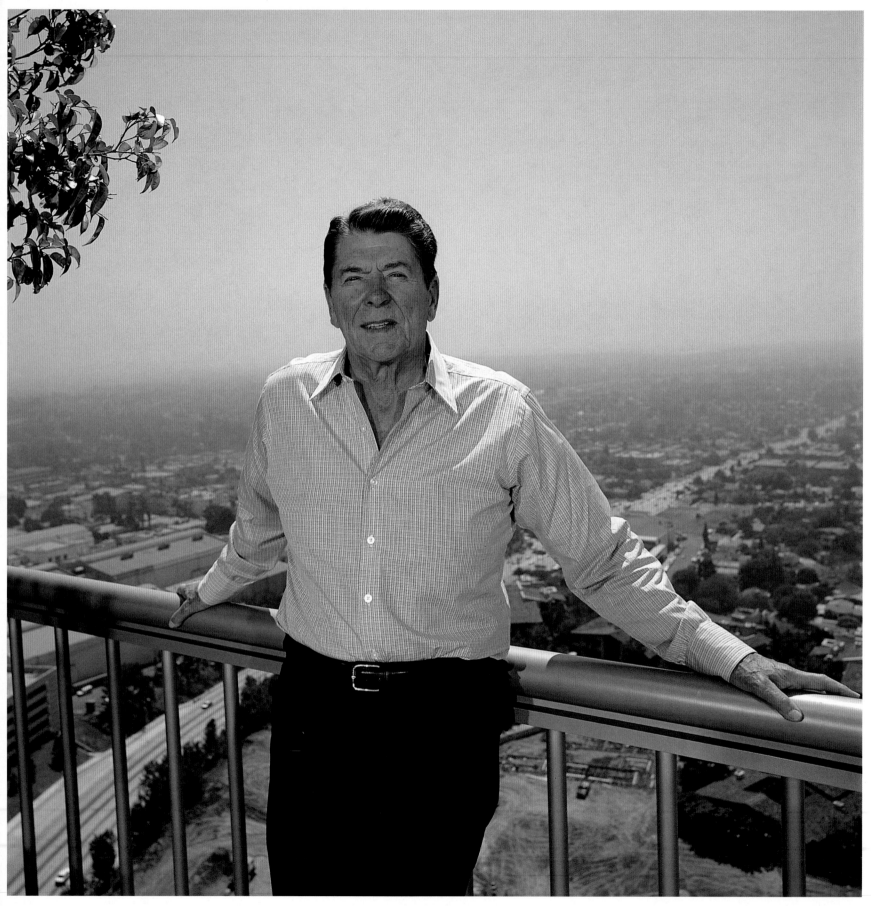

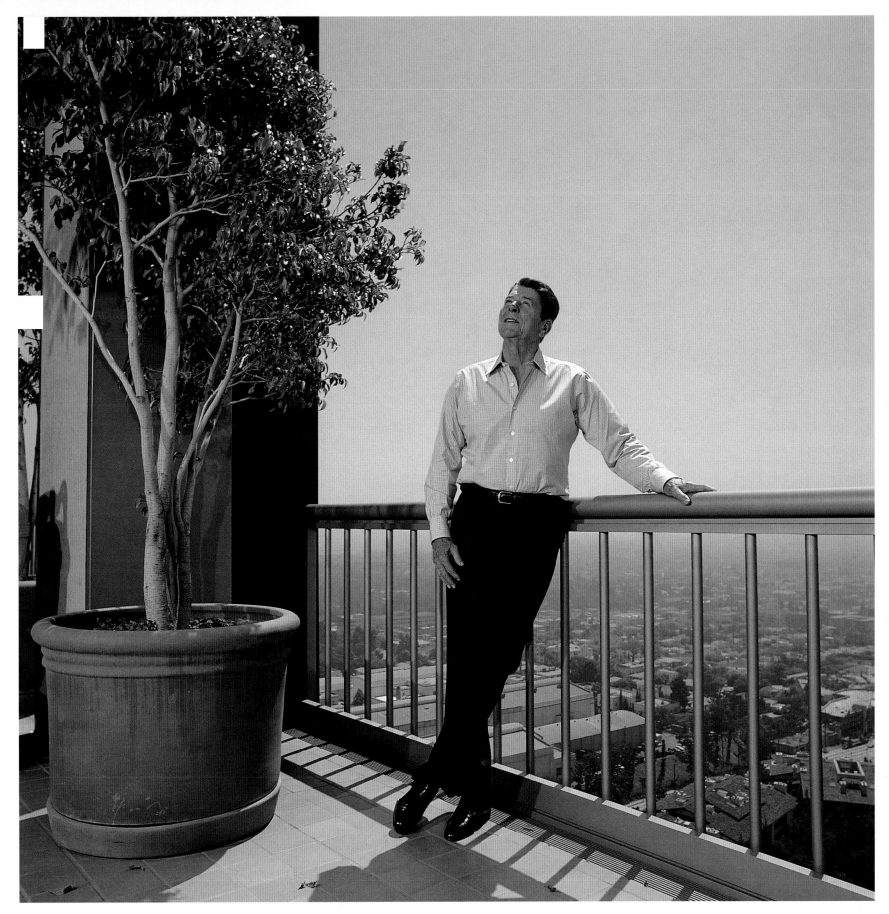

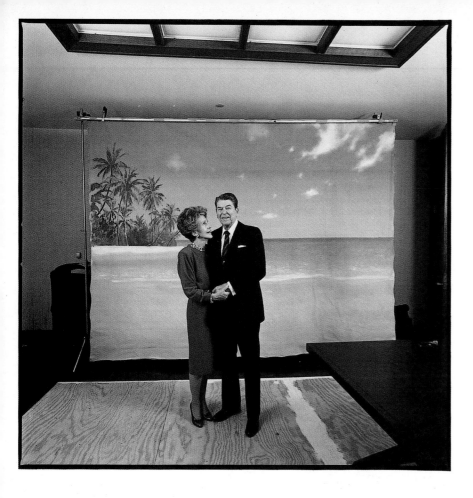

WHEN PRESIDENT REAGAN LEFT OFFICE in January 1989 at the end
of his two terms, the Reagans moved back to California to a
home in Bel Air. His popularity was immense and had been
crucial to the presidential election of Vice President George Bush.
On February 2, 1989, I photographed the Reagans for a story in
People magazine about his life since leaving office. After taking
photos of the president at his desk with Nancy by his side, I put
up a canvas backdrop of a sunset, which seemed fitting at the time
because the newspapers were saying he was going to ride off into
the sunset after leaving office.

Little did I, nor the rest of the world, know what sad news
Reagan would have for his country five years later. It goes with-
out saying that the Reagans' life changed after the announcement
in November 1994 that the former president had Alzheimer's
disease; however, their great love for each other did not.

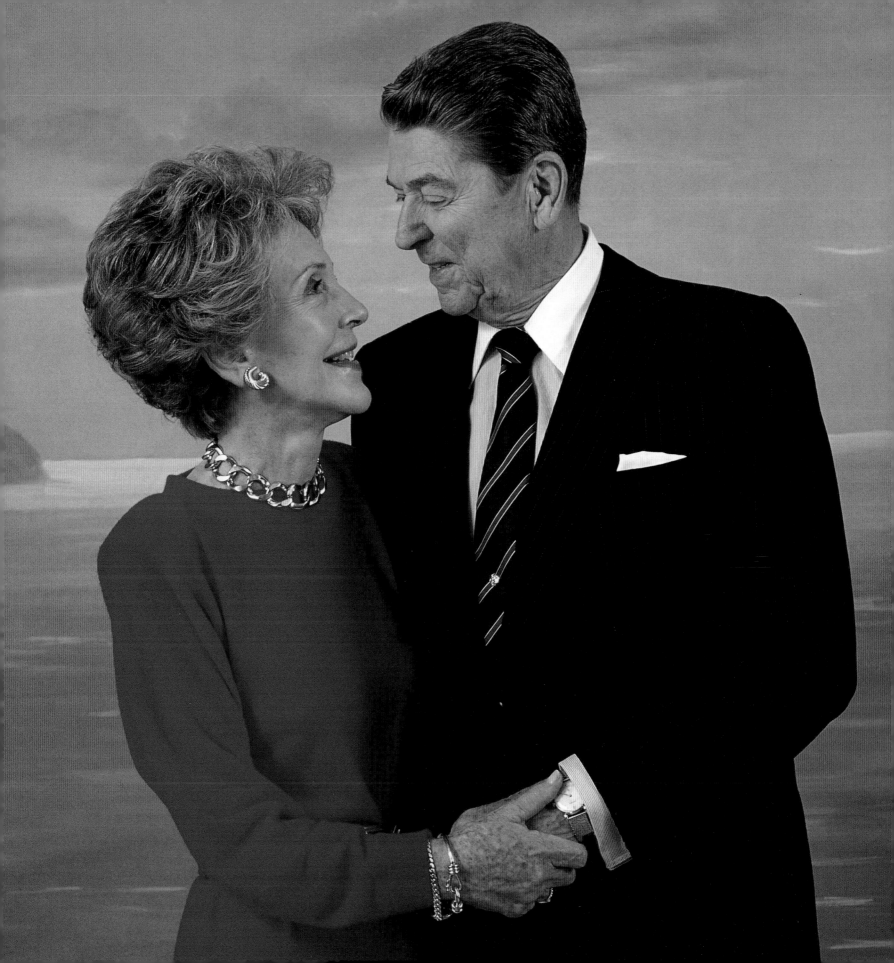

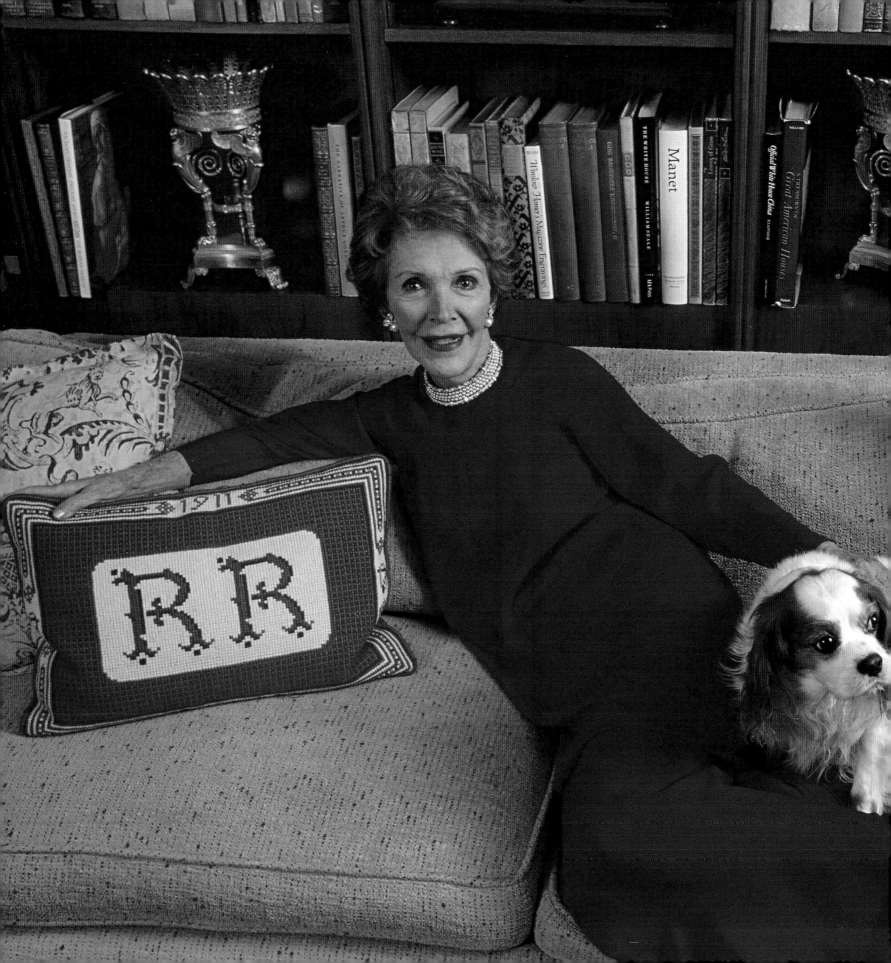

IN FEBRUARY 1995 Nancy agreed to be photographed by me once more at the Reagans' Bel Air home, for *Vanity Fair*. I received a call at my hotel asking me to arrive at 9:00 A.M. instead of at 10:00. I arrived early with my assistant, photographer Jonathan Delano. Nancy answered the door in her dressing gown; however, her hair and makeup were perfect.

I asked her to pay my respects to the president. She seemed pleased to tell me that he had been out playing golf the day before. She then showed me two gowns to choose from. I chose the long, red Galanos and she said that it was her choice too. Nancy offered me a coffee and then went to get dressed while Jonathan set up the lights. I asked her to sit on the sofa in the library. Her King Charles Spaniel, Rex, jumped up and made himself comfortable next to her as I began taking pictures. We chatted briefly before I left, and Nancy remarked that her hope was for the president to be remembered as the "Great Communicator."

THE PRESIDENT & MRS. REAGAN

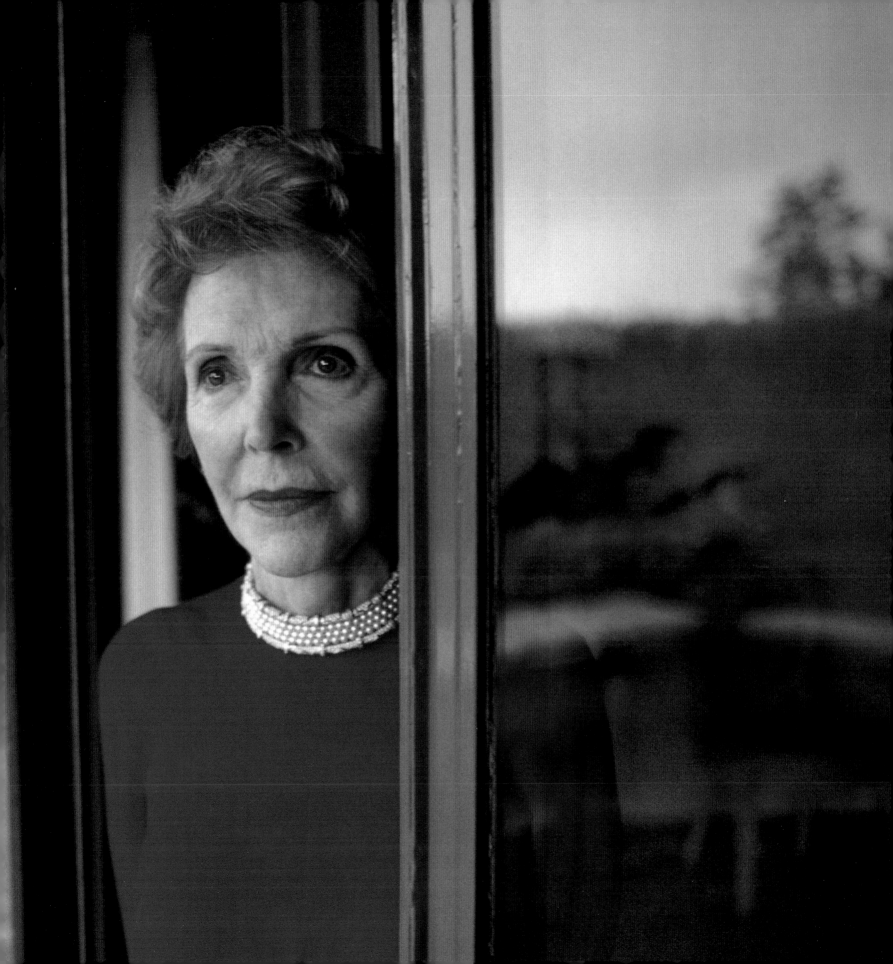

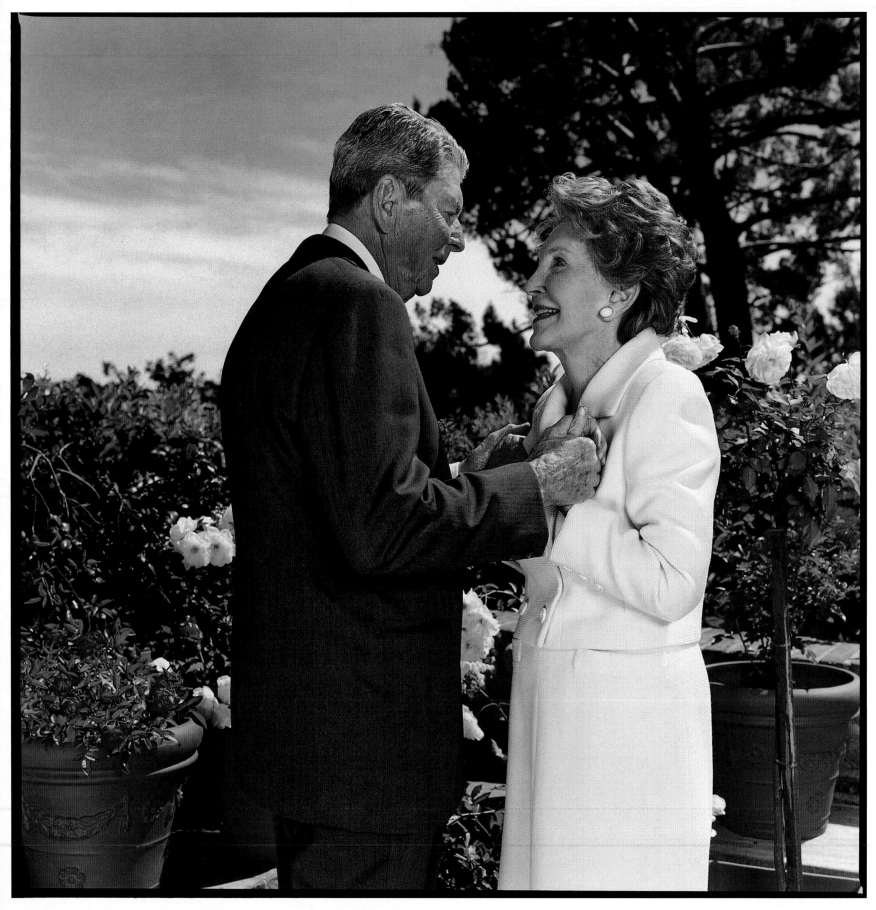

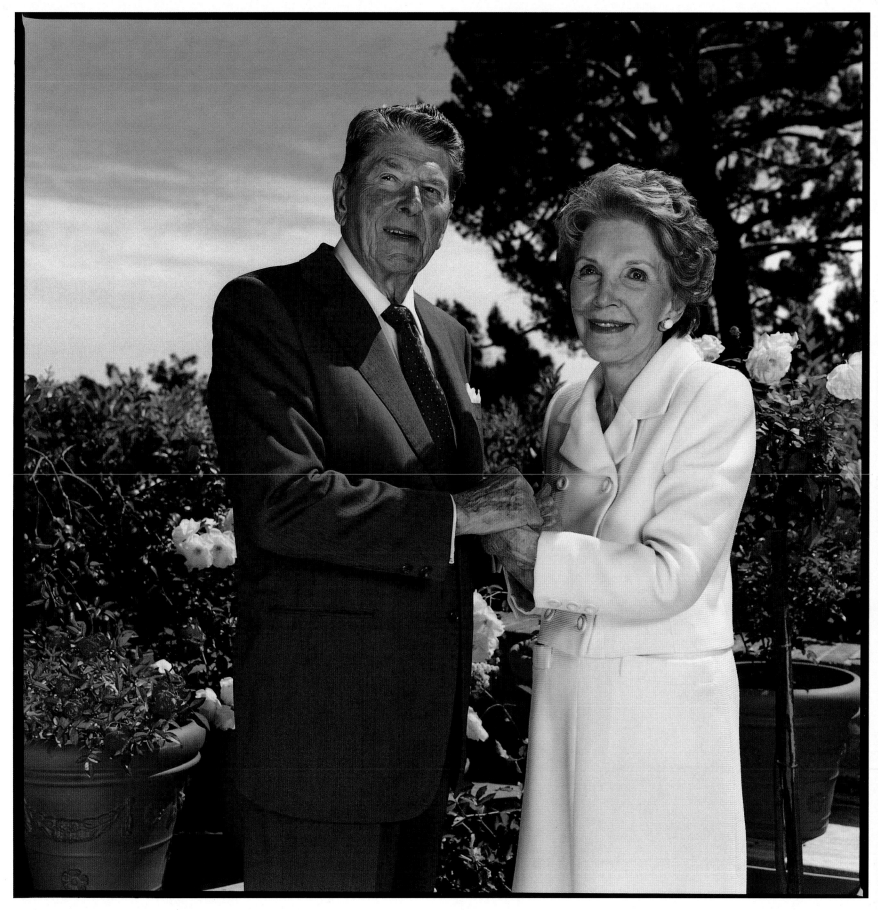

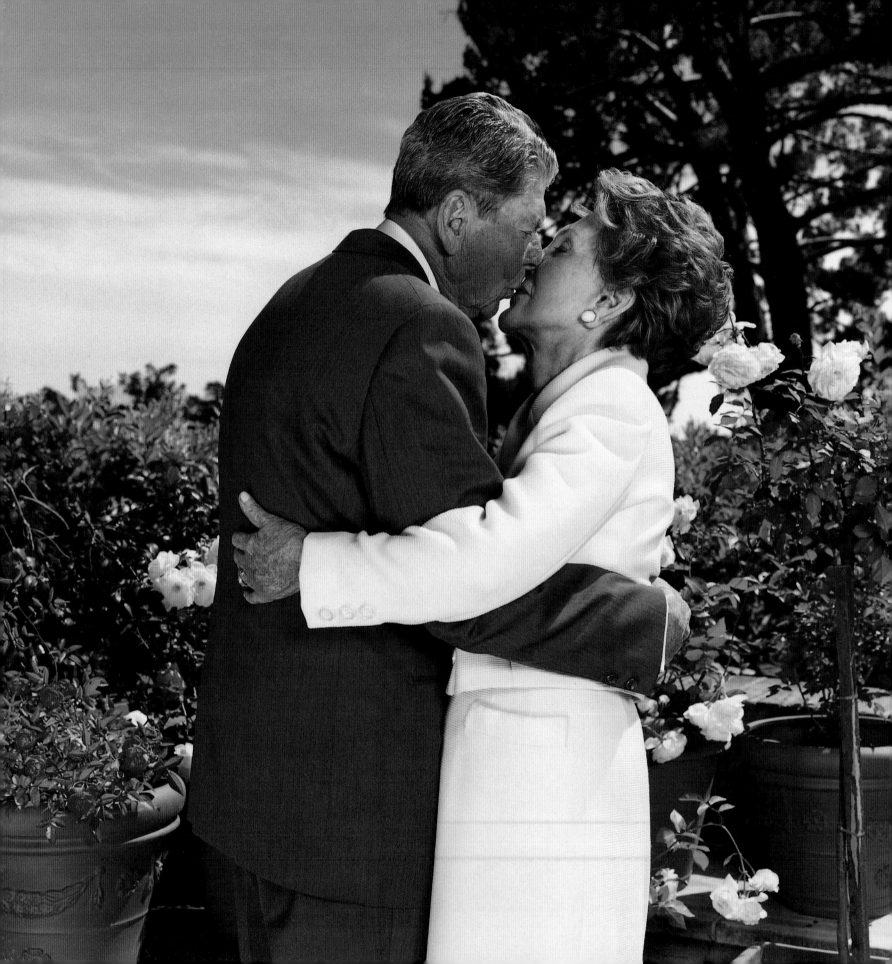

THE LAST TIME I PHOTOGRAPHED the Reagans together was on April 16, 1998. The photos appeared on the cover of the July issue of *Vanity Fair* and again inside the August issue. It had been three and a half years since the president's announcement that he had Alzheimer's disease. He looked fit and had great color in his cheeks as he walked into the garden of their Bel Air home. The couple stood together looking into each other's eyes as I had seen them do so many times before. I called out from behind the camera, "Give her a kiss." Smiling, President Reagan looked at me. "I can do that all right," he said as he turned and gave Nancy a kiss.

The photo session didn't last long, but it was filled with love. They were still a team, still by each other's side.

EDITOR: Gail Mandel

DESIGNER: Michael J. Walsh Jr.

DESIGN, TYPESETTING: Arlene Lee

PRODUCTION MANAGER: Stanley Redfern

LIBRARY OF CONGRESS CONTROL NUMBER: 2002114941

ISBN 0-8109-4232-1

PRINTED AND BOUND IN ITALY

10 9 8 7 6 5 4 3 2

HARRY N. ABRAMS, INC.
100 FIFTH AVENUE
NEW YORK, N.Y. 10011
WWW.ABRAMSBOOKS.COM

ABRAMS IS A SUBSIDIARY OF

LA MARTINIÈRE
GROUPE